IMAGES
of America

SMITHVILLE

To Neta —
We know you will
enjoy listening to the park
music(!) and living in
Smithville!

Carol Phillips Snyder

Paul V. Herring

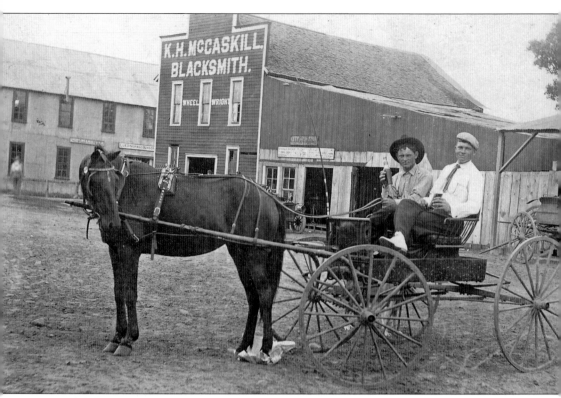

McCaskill Blacksmith existed from 1891 to about 1909, one of two or three in Smithville. In the 1800s, the "smithy" served as farrier, locksmith, gunsmith, the local hardware store, and was often known as the town's mechanical engineer. He could make or repair knives, axes, door hinges, wagon wheel rims, and generally anything made of wrought iron, and he often used his pliers to pull teeth.

IMAGES
of America

SMITHVILLE

Carol Phillips Snyder, David L. Herrington,
and the Smithville Heritage Society

ARCADIA
PUBLISHING

Published by Arcadia Publishing
Charleston SC, Chicago IL, Portsmouth NH, San Francisco CA

Printed in the United States of America

Library of Congress Control Number: 2008936537

For all general information contact Arcadia Publishing at:
Telephone 843-853-2070
Fax 843-853-0044
E-mail sales@arcadiapublishing.com
For customer service and orders:
Toll-Free 1-888-313-2665

Visit us on the Internet at www.arcadiapublishing.com

*To the visionary pioneers and entrepreneurial giants who came
before us, without whom there would be nothing to write.*

CONTENTS

ACKNOWLEDGMENTS

A heartfelt thanks goes to our coauthor, the Smithville Heritage Society, for use of their valuable museum and archives. Generous friends have donated pictures, documents, and other important items for over 30 years to preserve the history of Smithville. Tireless volunteers keep records in good shape and well organized. To all these people, we are truly grateful. The Smithville Railroad Museum, our sister museum, also contributed pictures and significant information to the authors.

Unless otherwise noted, all images in this book were graciously provided by either the Smithville Heritage Museum or the Smithville Railroad Museum, who always work hand-in-hand for the betterment of our city.

Others to whom we are in debt for sharing pictures, maps, their time, and historical information for *Smithville* include Smithville Public Library staff; *Smithville Times* staff; Brenda Page, city secretary; Bastrop County Clerk's staff; Bastrop Public Library staff; Fayette Public Library and Fayette Heritage Museum and Archives; Texas General Land Office staff; Texas State Library and Archives staff; Masonic Grand Lodge of Texas; Herzstein Library at San Jacinto Museum of History; Lisa Struthers; Dorothy Barton; Bruce Blalock; Sallie Skelley Blalock; Eulene Carter; Dorothy Cook; Silky Ragsdale Crockett; Billy Davis; Patti and Dennis DeWet; Pamela Duncan; Dan Ellis; Rev. Derwin Gipson; George Helmcamp; Crystal Herrington; Max Jones; Margaret Trousdale Klaerner; Beauty McDonald; the family of Donald Matocha; Joanna Morgan; Mike Morgan; Cherrell Rose; John Saunders; Margaret Ann Thetford; Gene Volcik; Janice Wallace; Ruth Stalmach Whitehead; Charles Williams; and Kevin Wolf.

The value of our access to both *Smithville: Then and Now*, by Valerie Johnson, and *Early History of Smithville, Texas*, by Silky Ragsdale Crockett, was inestimable. The research done by these authors is impeccable and was used to verify facts. They paved the way for this book.

We were fortunate to have worked with Arcadia Publishing editor Kristie Kelly, who was our most enthusiastic helper.

Our spouses, Dennis Snyder and LaVerne Herrington, provided the perfect level of support, encouragement, and, at times, assistance. They always made us feel like we were working on something very worthwhile while writing *Smithville*.

INTRODUCTION

As its motto "Heart of the Megalopolis" suggests, Smithville is located in central Texas within the triangle formed by Houston, San Antonio, and Austin. Smithville evolved from a small settlement in pre-Texas Mexico in 1827 into the progressive city experienced by today's citizens and visitors. Through bravery, diligence, and maybe a bit of hardheadedness, pioneers and settlers and their descendants made it through the Texas Revolution, the advent of the railroad, motorized vehicles and more modern technology, floods and tornadoes, World Wars I and II, and the Depression and are leaping into the next century. Smithville is not unlike other small American towns—changing with the times but always keeping an eye on the legacy that brought it this far.

Through historical photographs, many of which are previously unpublished, and hopefully informative captions, Smithville's history is presented more or less chronologically, unfolding logically as turns of events and transitional periods in the town's development occurred. For those not familiar with Smithville, have fun learning about this engaging town's history. For the Smithville native, hopefully these photographs and short narratives will nudge memories and include favorite people or stories.

Emphasis on historical accuracy is important while presenting a broad-brush spectrum of interesting involvements as the city has moved through the impacts and influences of characters, events, time, and technology. Specific focus has been directed to some of the many individuals who have made noteworthy contributions and who provided outstanding and visionary leadership toward the beneficial development of our state and our city.

The authors invite you to relax and enjoy this recount of Smithville's proud heritage.

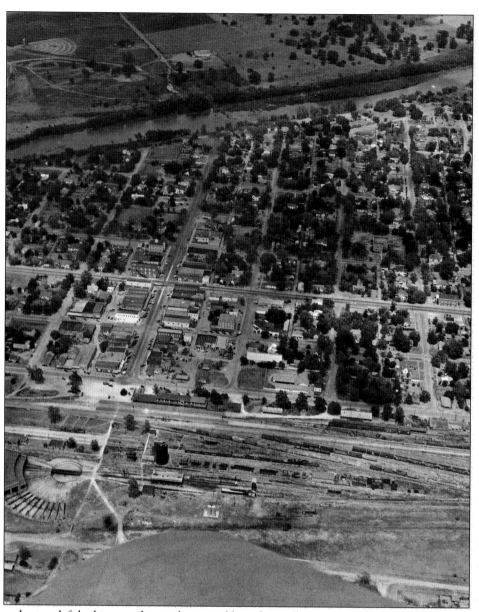

From bottom left looking northeast, the turntable and roundhouse maintenance facility highlight the M-K-T rail yard in Smithville, while the historic downtown business district occupies the left center of this late-1940s aerial photograph. The historic residential areas are situated among the many majestic shade trees within the city. Across the Colorado River, the Riverside drive-in theater is seen in the upper left corner and the American Legion hall near top center. Nearing the end of its life, the old Main Street river bridge routes traffic into town from the north. Old Smithville was originally situated along the river near the picture's right border. The original settlement of Gazley Prairie was located just off the lower left quadrant of the photograph on Gazley Creek. Central School stands out about right center on historic Block 16, and closer to the river, the movies *Hope Floats* and *Tree of Life* were filmed in historic homes. The central block of Main Street contains the tallest building in Bastrop County, and the gone-but-not-forgotten city hall building with its white cupola can be readily detected.

One

PIONEERS AND SETTLERS

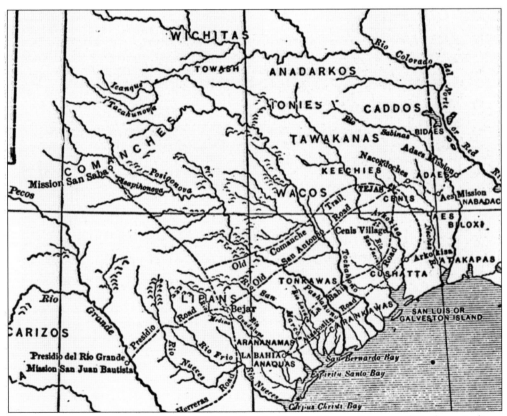

Before American pioneers moved into where Smithville would grow, Lipan and Tonkawa Indians already lived there. Nomadic buffalo hunters who held an uneasy peace with the Mexicans, the Tonkawa eventually formed an alliance with Stephen F. Austin and the Americans and helped them in battles against Comanches and Wichitas, according to Dudley G. Wooten's *A Comprehensive History of Texas: 1685–1897* (1898).

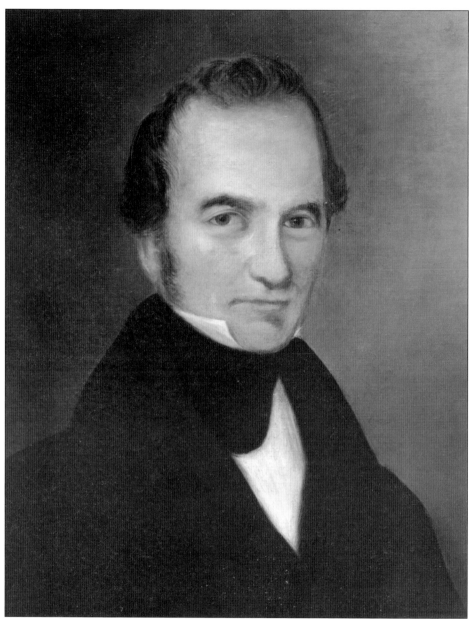

Stephen F. Austin, the founder of Anglo-American Texas, was born in Virginia in 1793. He grew up in what is now present-day Missouri, later moving to Arkansas Territory. During this time, his father, Moses, had come to Spanish Texas and received an empresarial grant to bring 300 Anglos to Texas. After his father's death, Stephen took over the empresarial grant and arrived in Texas in August 1821, learning in transit that Mexico had declared independence from Spain. He worked extensively with the Mexican government to enact immigration laws, making it possible for Anglo-Americans to colonize the Mexican territory. After relations with Mexico began to dissatisfy the colonists, he became a military leader fighting for Texas's independence from Mexico. Following the defeat of Santa Anna, Austin lost his candidacy for president of the new Republic of Texas but became its short-lived first secretary of state. He died on December 27, 1836, at age 43, from pneumonia. (Courtesy Texas State Library and Archives Commission.)

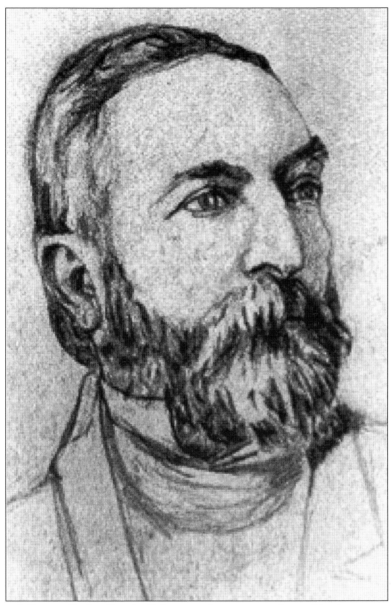

Dr. Thomas Jefferson Gazley, Smithville's original pioneer settler and businessman, arrived in December 1827 and brought his wife and children in 1828. On April 29, 1829, he applied for a license to practice medicine in San Felipe de Austin, where he was soon appointed clerk of the *ayuntamiento*, the local governing body of the Mexican government. At the Convention of 1832, he was appointed to the committee of safety and vigilance for the District of Bastrop. He was a delegate to the Convention of 1833 and one of three representatives from Mina, as Bastrop was then called, for the Convention of 1836 at Washington-on-the-Brazos. There he signed the Texas Declaration of Independence. He was physician for the Army of Texas in 1835 and 1836. After the Texas Revolution, Dr. Gazley practiced law, became a judge, was elected Republic of Texas congressman, and served as grand senior warden of the Masonic Grand Lodge of Texas. Dying in 1853, Gazley was reinterred from his Smithville resting place to the Texas State Cemetery in 1937. (Sketch courtesy Texas State Cemetery.)

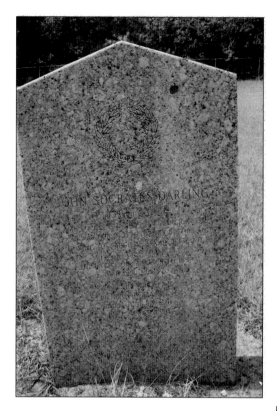

John Socrates Darling, born 1806 in Boston, Massachusetts, came to Texas just in time for the revolution. He participated as a "Texian" in the storming and capture of Bexar and the Battle of San Jacinto and later gained repute as an Indian fighter. He participated in Fayette County government, raised his family, and died in 1870. (Courtesy David L. Herrington.)

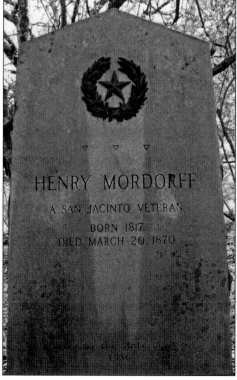

A presence of honor and dignity surrounds this Texas commemorative grave marker, resting on a hillside just south of Smithville. Recruited in New Orleans by Capt. Amasa Turner, Henry Mordorff fought in Turner's company at the Battle of San Jacinto. He lived on his bounty land in Bell County for a while and later purchased a farm near Smithville, dying here March 20, 1870. (Courtesy David L. Herrington.)

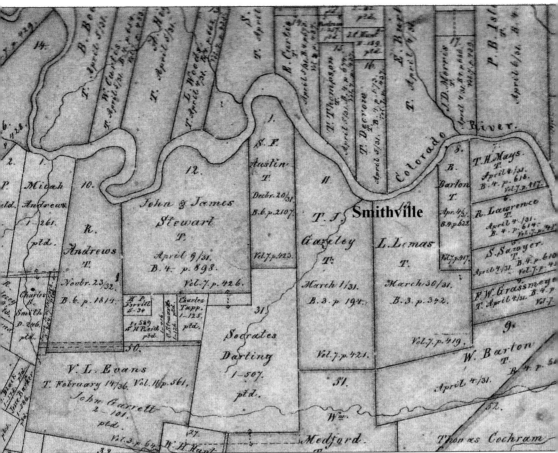

Stephen F. Austin recruited stalwart types to accept the challenge of settling his second Texas colony. Near what would become Smithville, Thomas Gazley settled adjacent to land that Austin himself would choose and also to land that John Socrates Darling later selected. Neighbors Richard Andrews, called "Big Dick" because of his immense size and strength, and his brother Micah both became known as Indian fighters. Situations between the Mexicans and the Texians became restless, as history would have it, and the Texians started rebelling. Richard Andrews fought and was wounded at Gonzales, where the first shot of the Texas Revolution was fired, then lost his life 26 days later at Concepcion, becoming honored as the first Texan to die in the Texas Revolution. Brother Micah Andrews went on to serve as first lieutenant of Capt. Jesse Billingsley's company at the Battle of San Jacinto and then later settled in La Grange. He died in 1849 never having married. Destiny brought this quintet together, and they individually went down in history as true Texas heroes. (Courtesy Texas General Land Office.)

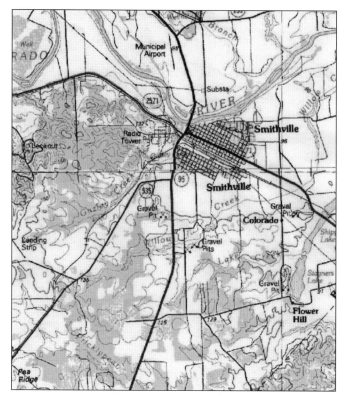

Thomas Gazley's choice of locations for his land grant is clearly depicted by a current topology map of the Smithville area. He selected fertile land that overlooked the Colorado River at the mouth of a small creek, near a crossing area used by roaming buffalo herds. The landmark fossilized structure, which extends nearly across the river here, might have facilitated early crossings. (Courtesy U.S. Geological Survey via TerraServer-USA.)

Thomas Jones Hardeman's home, built around 1840, was located 3.5 miles northwest of Smithville. Born in Tennessee in 1788, a soldier, pioneer Texas settler, judge, and politician, Hardeman was a captain under Gen. Andrew Jackson at New Orleans in the War of 1812 and served both in the Republic of Texas Congress and the state legislature. At his suggestion, the capital of Texas was named Austin. He died in 1854.

John Fawcett Jr. was once one of the most prosperous men in the county, operating a gin and sawmill and organizing a cotton factory. Mainly he enjoyed raising, training, and racing horses in Houston. Born in England in 1815, he came to Texas in 1836–1837 but did not arrive in Bastrop County until 1845. He married Marion Washington Burlington and then Sarah E. Rhem and had seven children. In 1847, Thomas Hardeman sold him 150 acres in the Thomas Gazley league. Later, through his wife Marion's inheritance, Fawcett's land was increased to 3,100 acres. In 1859, he built this lavish, two-story house, with an ebony and gold leaf mantel, out of bricks handmade by slaves. The house sat on a bluff overlooking fertile lands that stretched 2 miles to the Colorado River. Sadly, it burned in the 1920s.

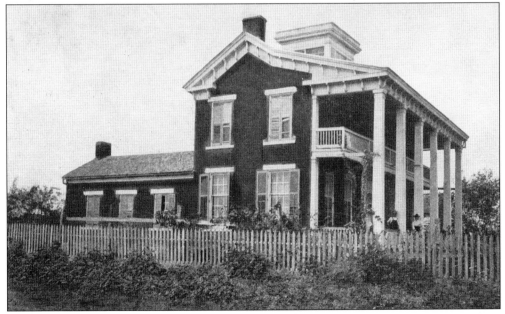

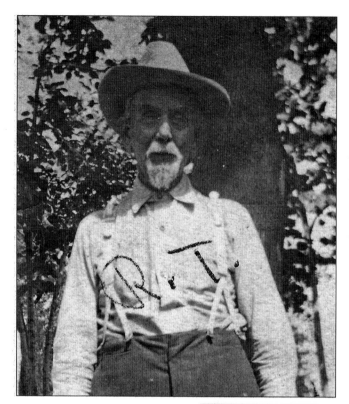

A man of Scotch and Welsh extraction, R. T. Wilkins came to Texas in the 1850s. He fought in Walker's Civil War company all over Louisiana and Arkansas. After returning home, he ran his father's farm, took employment as a store clerk, and married Josephine Fawcett. In 1871, he bought a farm of 400 acres overlooking the Colorado River valley, about 3 miles west of Smithville.

Born in Louisiana in 1844, Robert Thomas Sawyer settled in about 1850 with his family south of Smithville on the Fayette County line near Barton's Creek. At age 16, he became a scout for the 5th Texas Cavalry, Company I, riding his bay horse, Seven-Up, throughout the Civil War and bringing it back home with him. He married Mary Ann Jeffery and later Arsenath Scallorn, producing 13 children, before he died in 1927.

16

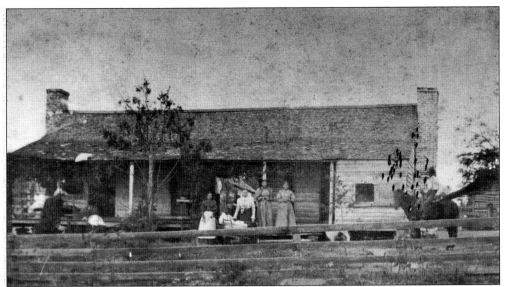

One of the oldest communities in Bastrop County, Alum Creek, was settled about 1829, and a private school was founded by 1835. The post office was established in 1851, and it was also the home of this family standing on the porch. By 1884, Alum Creek's population was 200 and supported three mills, two general stores, a blacksmith shop, and saloon. By the mid-1980s, only a few houses and antique shops remained.

The stagecoach was the first commercial overland transportation system to serve Smithville. One of the route's way stations was located 3.5 miles northwest of town at the Jones-Powell house. In later years, the steam train outpaced the horse-drawn coaches. Although this photograph shows a state of neglect, the house was relocated to Bastrop in the 1980s and restored to near original condition by Jerry Wagner.

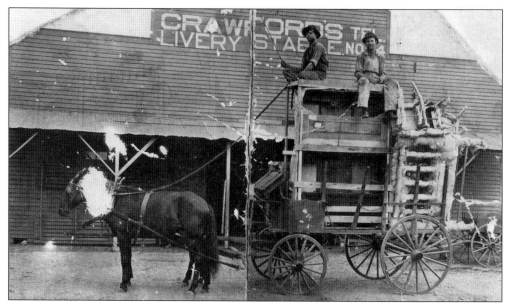

In early days of Smithville, the stagecoach stopped at the Crawford Livery Stable, conveniently located on Olive Street, just north of the rail yard and adjacent to two blacksmith shops. As cars replaced horses by 1918, the livery transitioned into Turner's Studebaker automobile dealership. During 1932, Marrs Undertaking moved to the property, and today the remodeled historic structure houses the Marrs-Jones Funeral Home.

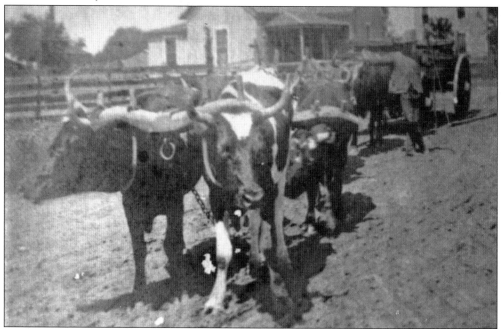

Original settler Thomas Jefferson Gazley probably utilized oxen to pull his cartloads of belongings from New York state to his head-right land grant at Gazley Prairie, now Smithville. Oxen, which were usually adult male steers trained as draft animals, were more sure-footed and could pull longer as well as harder than horses. In 1999, oxen were used to pull "Old" Joe Cole's funeral cortege to his grave site.

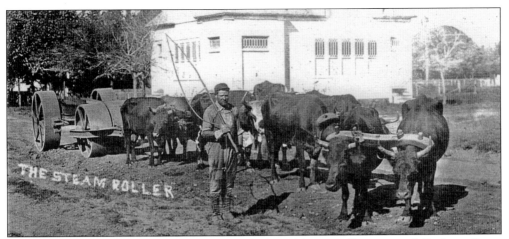

In the early 1900s, this set of harnessed oxen pulled an old street roller to smooth Burleson Street at the corner of Fourth Street, in front of the First Christian Church in Smithville. Main Street was paved between 1925 and 1928, but other streets were not paved for a long time after that.

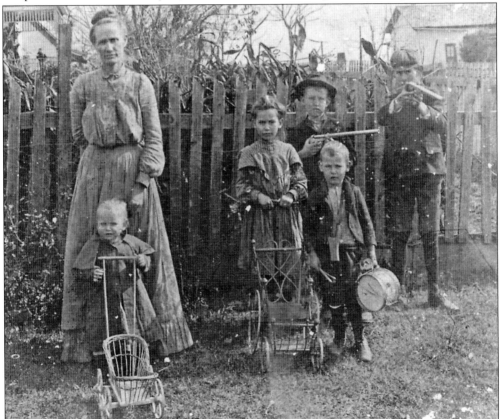

The McKinney family shows off Christmas gifts in 1904—toy guns, strollers, and a drum. Maggie (Mrs. J. P.) McKinney and baby Aileen pose with, from left to right, Hazel, Lawrence, Manson, and Lucian McKinney. Aileen married Charley Webster in 1920, and they parented daughter Margaret. During World War II, Aileen served in the Women's Army Corps and was, along with other World War II women, later honored by the Queen of England for her service.

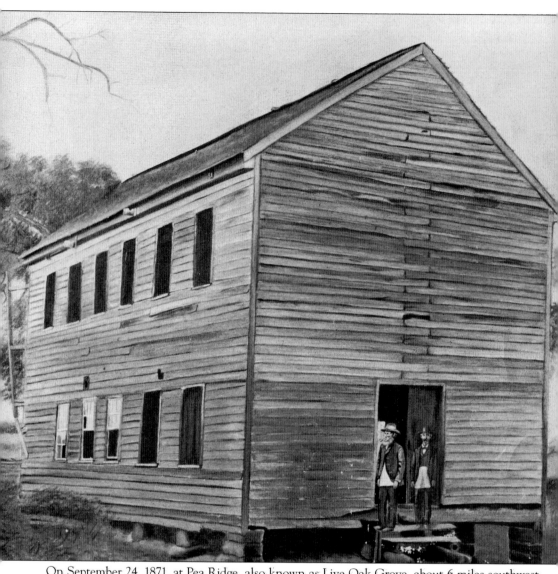

On September 24, 1871, at Pea Ridge, also known as Live Oak Grove, about 6 miles southwest of present-day Smithville, Rev. J. M. Renick organized the settlement's first church, Cumberland Presbyterian, which held services outdoors and at members' homes. In 1875, the J. Nixon Masonic Lodge was chartered and promptly erected a Lodge building. The Lodge readily granted approval for the Cumberland Church to use its lower floor on Sundays for religious services and allowed the local children's school to use the same area on weekdays as a classroom. In May 1888, the Nixon Masonic Lodge moved to Smithville's Block 16. In 1889, the Cumberland Presbyterian Church moved to Smithville, again meeting in the schoolhouse (the lower floor of the new J. Nixon Masonic Building) until the Methodist church building was completed. The Methodist facilities were shared with the Presbyterians and the Baptists until 1896, when Cumberland decided to build its own church building on the corner of Third and Burleson Streets. Here W. J. Nixon stands on the left and Rev. J. M. Renick on the right.

This tintype taken about 1879 pictures Cumberland preacher James Madison Renick and his wife, Sarah Elizabeth Hall. Renick was born in 1842 in Missouri, came with his parents to Texas in 1846, and was ordained in 1869. He started the First Presbyterian Church of Smithville and later served as chaplain of the House of Representatives. James and Sarah, who was born in 1846 in Kentucky, had three children.

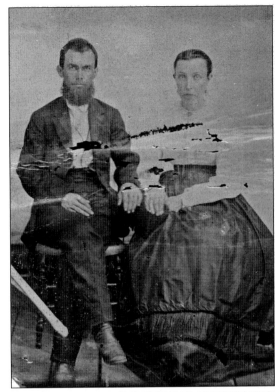

Rev. James M. and Sarah Renick celebrate their golden wedding anniversary February 14, 1916, in front of the old First Presbyterian Church at 300 Burleson Street (below). They married February 14, 1866, in Winchester, Texas, and here stand (first row, center), surrounded by friends and family. Having served as pastor of First Presbyterian from 1871 to 1883, 1888 to 1898, and 1900 to 1901, Reverend Renick died March 12, 1920, and Sarah followed on March 7, 1926.

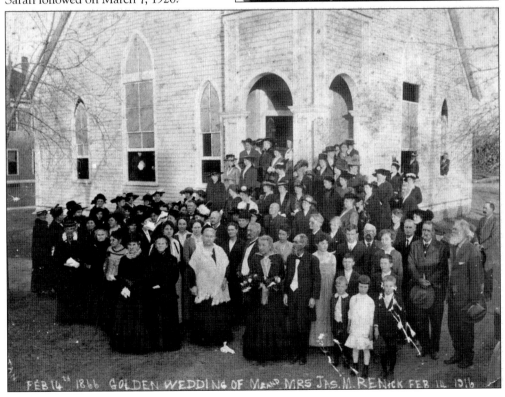

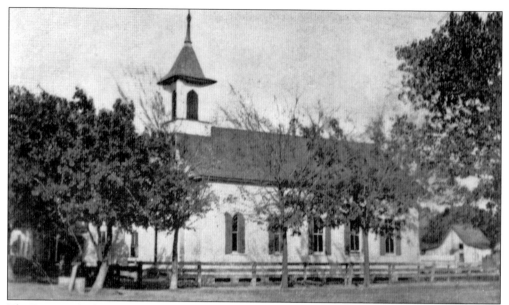

The First Methodist Church was organized in 1888 by Rev. H. W. Haynie. In 1889, the Smithville Town Company donated a lot for the church building, which was completed in 1893. This facility was also used by Presbyterians and Baptists, since they had no building. It was rebuilt in brick in 1912, then after a fire in 1922 was reconstructed to the currently used church.

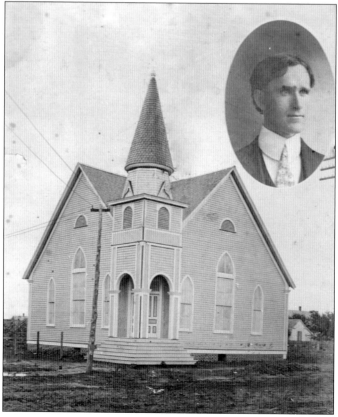

The Cumberland Presbyterian Church was built in 1896 on a lot donated by the Smithville Town Company at Third and Burleson Streets. J. M. Renick was pastor at this time. In 1906, the church united with the Presbyterian Church U.S.A. and became First Presbyterian Church U.S.A. The congregation had outgrown this building and constructed a new one by 1924. Minister R. E. Robertson is pictured here.

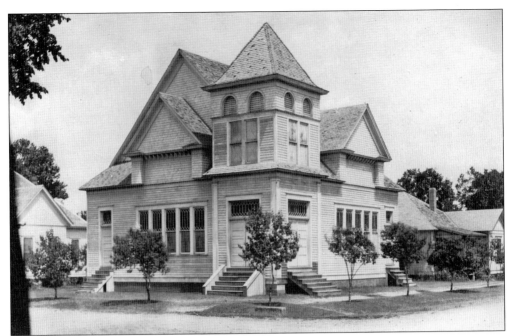

In April 1896, the First Christian Church (Disciples of Christ) was organized at the Maney Opera House. They met in the opera house and in the Presbyterian church until 1903. The present church was built that year by C. H. Turney and M. M. Turney. Added in 1958 was a church annex used for Sunday school classes and as an auditorium.

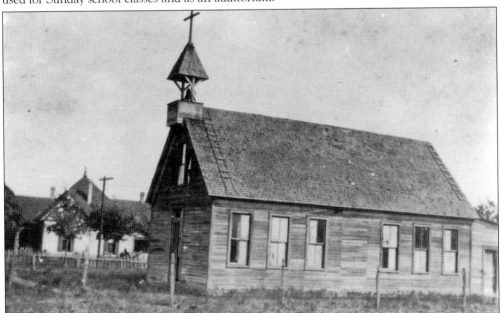

When the Missouri, Kansas, and Texas Railway came to Smithville, a lot of employees who were Catholics came from other parts of the country. They constructed this tiny wooden building in 1896 and named it the Church of St. Paul the Apostle. This church, photographed by J. J. Stalmach in 1912, was replaced in 1913 on the same lot at Third and Mills Streets. Pennsylvania native Fr. Charles S. O'Gallagher became the first pastor.

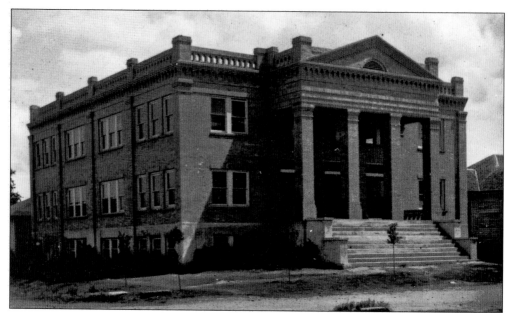

Originally meeting with the Methodists and Presbyterians in 1890, the Baptists organized their own congregation in 1895, including the Powells, Coles, Fawcetts, and Burlesons, and erected a one-room frame building on land donated by the Smithville Town Company. In the early 1920s, the frame building was torn down and this $20,000 brick structure was constructed to accommodate the large and growing membership. Since then, the First Baptist Church has grown immensely.

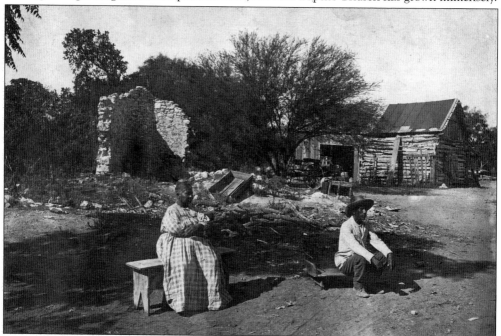

Late afternoon shadows signal the end of the workday for this rural couple, who seem to be contemplating the day's achievements while resting after their labors. This 1900 setting, with small log barn and wagon in the background, was typical for many of the early pioneers and settlers who came to live in this area.

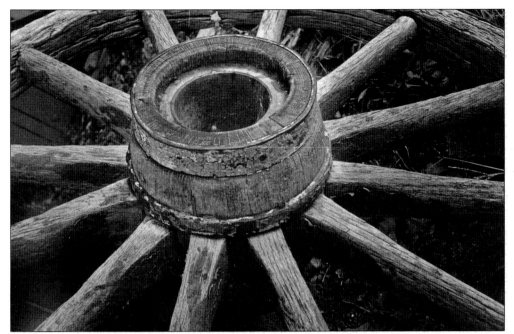

Oxcarts, cargo wagons, and covered wagons that early settlers used to traverse rugged terrain and water crossings, en route to the Texas frontier, all rolled on handmade, steel-rimmed wooden wheels assembled by wainwrights, wheelwrights, and blacksmiths. This weathered artifact retained its memories for "Old" Joe Cole as it resided near his historic log cabin home near Smithville.

Worn and weather-beaten, these old trailer remnants spawn visions of early pioneers traveling to Texas in oxen-drawn overland wagons and prairie schooners. Imagine for a moment that an entire family with all of their worldly possessions would fit into one of these conveyances and succeed in fording rivers and crossing the hundreds of miles of varied terrains to reach the frontier of Smithville and Bastrop County.

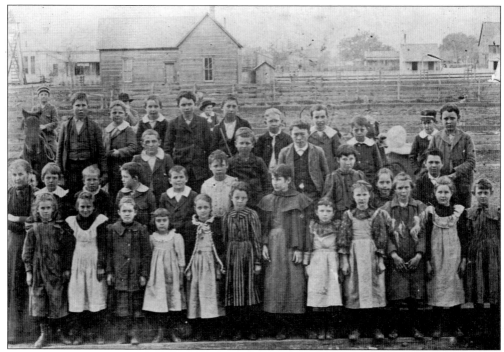

This photograph depicts how formal education began in the early to mid-1800s. Concerned citizens funded the early schools, which met at places such as Gazley Prairie, where A. C. Wilkes taught; at Pea Ridge, where they met in a lodge hall; and on Main Street in Old Smithville, where Sadie Fawcett, John Fawcett Burleson, and Mina Fawcett studied in a one-room schoolhouse.

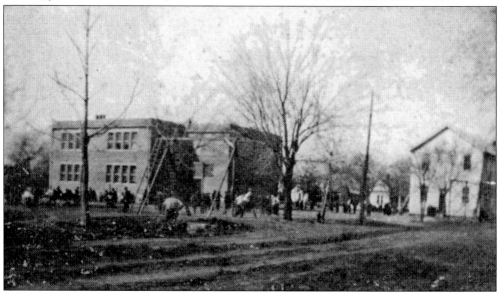

When the J. Nixon Masonic Lodge moved from Pea Ridge to Smithville in 1888, children once again attended school on the ground floor of its newly constructed building. Public education gained favor after 1895, and the city fathers took on the responsibility of education for the town's children. They bought the lodge's building and the surrounding Block 16 to provide for future expansion. S. E. Gidney became Smithville's first school superintendent.

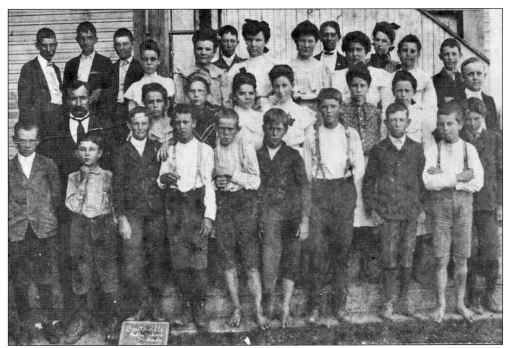

The 1903–1904 seventh-grade class poses in front of the first true public school building the town had erected. This 10-room, L-shaped, two-story, wood-framed building was used to educate the white children; a modest two-room frame building was erected at another location for black children. The wooden building was relocated in 1908, and in 1912, it was expanded for black students.

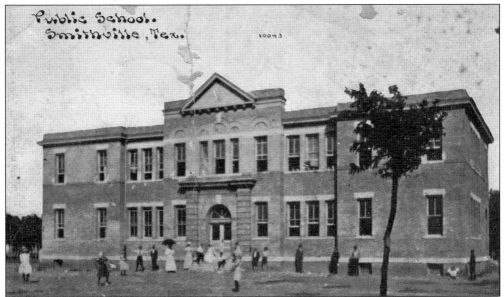

Central School children enjoy the playground of the new 1908 brick structure that would serve students until 1973. The facility was built for $25,000 and paid for through a bond election. Local businessman Emil Buescher was school president at the time. In later years, the building continued to serve preschool children through the Head Start Program. Although it remains intact, it is no longer used for educational purposes.

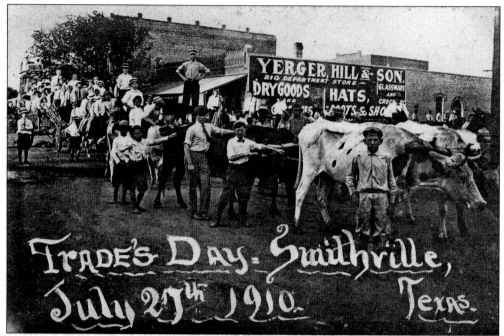

Virgil Rabb III stands next to the oxen pulling a wagon in the Trade Days parade on July 27, 1910. Trade Days was the first known annual spring celebration in Smithville—an opportunity for farmers and ranchers to bring their livestock, produce, and other farm products to town, show them off, and sell them. Townspeople would join in the trading with homemade breads and pastries, jellies, quilts, and the like.

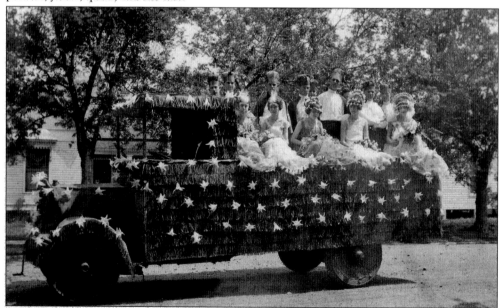

This World War I truck, decorated for a parade in the 1920s or 1930s, included passengers Julius Roensch, Dain Whitworth, Elsie Psencik Janak, Barbara Wray, and others. Smithville's spring festival was called "Trade Days" into the 1940s, then "Frontier Days," and finally "Smithville Jamboree" starting in 1957.

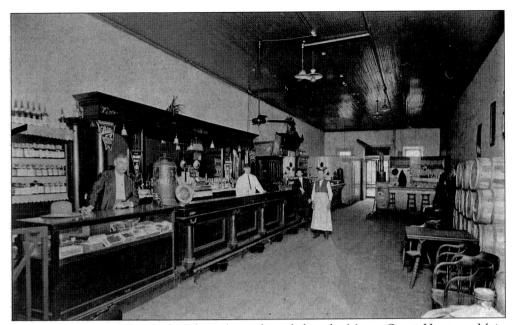

Thirsty adults found the Shade Saloon, located just below the Maney Opera House on Main Street, to be a comfortable and friendly atmosphere where Schlitz beer and more stout beverages could be safely enjoyed until Prohibition shut it down. Note the brass foot rail, domino table, stacked beer kegs, and humidor full of cigars.

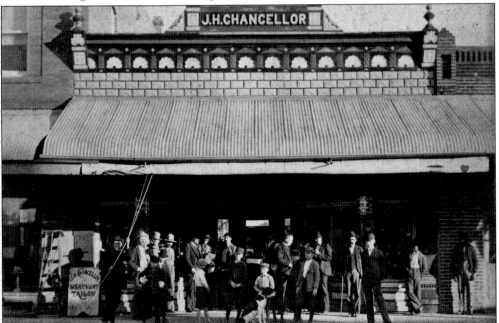

Young C. L. Saunders, with his bird dog and constant companion Lee, assembled with other prominent citizens in this c. 1898 depiction of a promotional event about to unveil itself. Note the freshly hung furled banner with visible heart or valentine exposed and the background ladder on the left side. J. H. Chancellor, a prominent citizen and businessman, built the store in 1893 and further broadened the mercantile spectrum in the city.

Julia A. Moseley Egleston (the original Dutch spelling) and husband, Stephen vanRensselaer Egleston, moved to Bastrop from North Carolina. As a carpenter, Egleston constructed several homes and business buildings there. He fought in the Texas Revolution against Mexico, then returned home to Bastrop in 1836. In 1839, he was killed by Native Americans at his home. Julia raised their seven children and died in 1886 at the age of 84 years. (Courtesy Margaret Ann Thetford.)

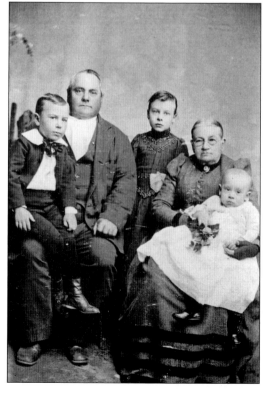

Zina Peter Eagleston, son of Stephen and Julia, was six when his father died and at eight was working to support his family. At 14, he joined the Texas Rangers fighting in the Mexican War. Zina was a blacksmith, became a rancher, fought in the Civil War, and retired to Smithville, becoming a leading commercial and residential real estate owner. He married Rebecca Scobey and had two children. (Courtesy Margaret Ann Thetford.)

Zina's son, Edward H. Eagleston, by 1891 was a partner in Smithville Gin Company and a saloon owner. He married Mollie Clark, and they had four children. Eagleston served on the city's first Board of Equalization, on the school board, and on the city council. He became a large landowner around Smithville and was a charter stockholder in the First National Bank of Smithville. Edward died in 1929. (Courtesy Margaret Ann Thetford.)

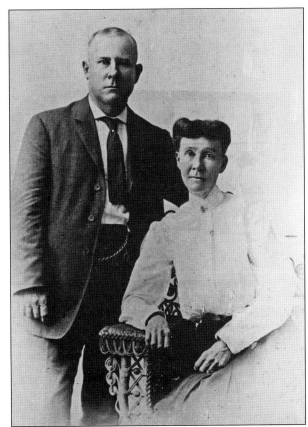

In 1907, Lucile Eagleston looks right at home sitting behind her grandfather, Edward Eagleston, on his workhorse. In earlier days, the grocery store behind them was her grandfather's saloon at the corner of Main and Second Streets. Next door to the grocer is a cobbler, and buggies can be seen parked at businesses on both streets. (Courtesy Margaret Ann Thetford.)

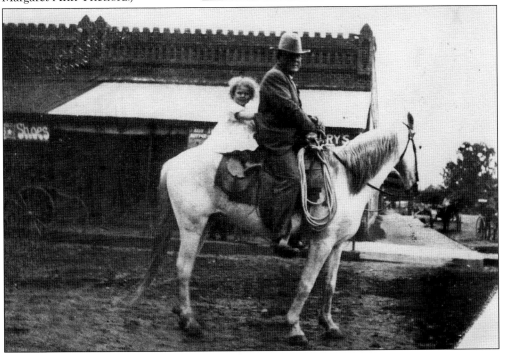

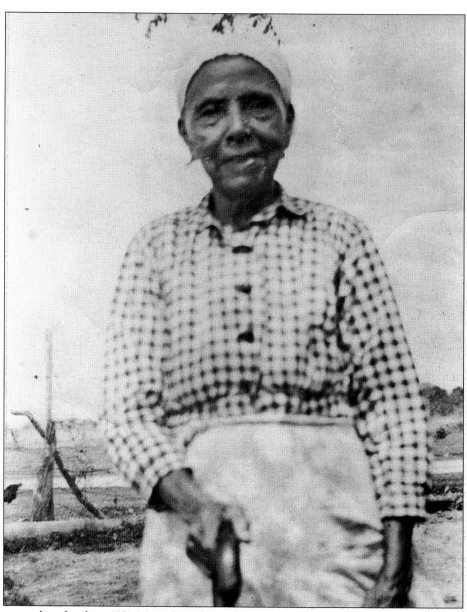

Born to a slave family in 1851, Miranda Ricks Griffin came to the Smithville area with her mother, Gaberella Ricks, and stepfather, Henry Tolbert. When she finished school, after helping her stepfather gin cotton day and night, she wanted a different life for herself and ordered a doctor book she had read about. From that beginning, she became a midwife for the remainder of her life. Miranda married Nathan Griffin, and they had 11 children. In time, Miranda worked for the well-respected Dr. C. C. Owens until she was 98 years old, often driving her horse and buggy to deliver babies. Dr. Owens, an African American native of South Carolina, graduated from Meharry Medical College in Tennessee in 1910, moved to Smithville in 1912, and set up a medical practice above the Mize Drug Store in the Hill building on Main Street. He was patronized by both black and white citizens and was known to be honest and kind, both as a person and as a doctor. Miranda Griffin lived to 103, dying April 28, 1954, and Dr. Owens died February 10, 1958. (Courtesy Beauty McDonald.)

Two

TRANSPORTATION
AND GROWTH

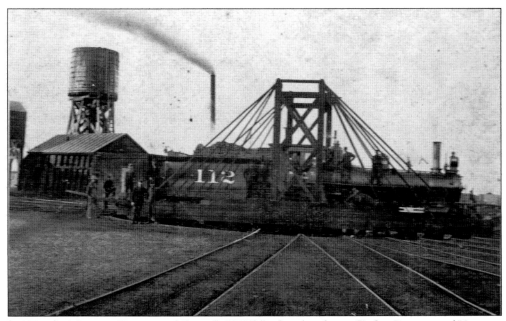

In 1891, the Missouri, Kansas, and Texas (MK&T) Railroad took over Taylor, Bastrop, and Houston (TB&H). In 1894, the MK&T established central shops in Smithville, their first yard operation south of Waco. It operated into the 1950s. This gallows turntable is the first of three ultimately constructed here. The turntable, located outside the roundhouse, operated on a pivot to divert locomotives onto a specific track.

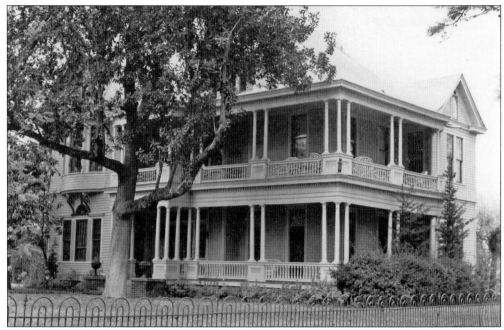

After the TB&H and MK&T railroads had come through Smithville, Murray Burleson with J. A. Hooper and Joseph D. Sayers formed the Smithville Town Company for the purpose of establishing a town. In 1894, Murray Burleson, acting individually and also as a partner of the Town Company, directed three land gifts to the railroad to be used for a terminus. Burleson later built this home on Eighth Street for his family.

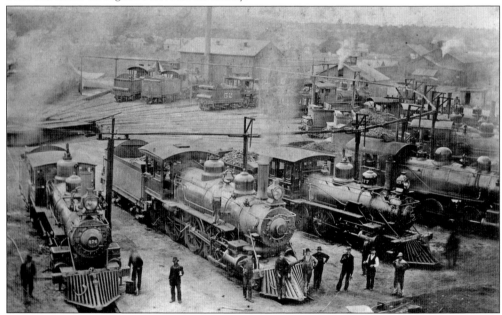

A requirement for the newer, larger locomotives that were being built, this 1904 pictured "arm-strong" turntable, so called because it took a "strong arm" to turn it, was the second turntable built in Smithville. This turntable was reconstructed sometime after World War I as part of MK&T's modernization.

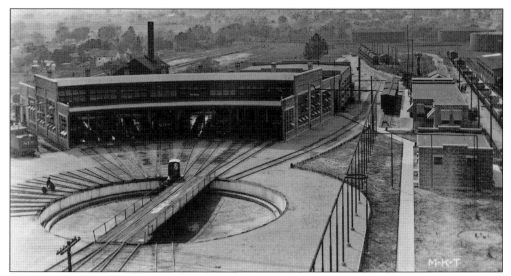

Smithville's roundhouse, built in 1897, was used for inspection, cleaning, repairing, and servicing of locomotives. After diesel engines started replacing the steam engines in the 1940s and 1950s, the roundhouse suffered from disuse. Smithville's railroad yard also included a wye, a track in the form of a "Y" leading from a main line, sometimes used for turning engines. (Courtesy Lower Colorado River Authority.)

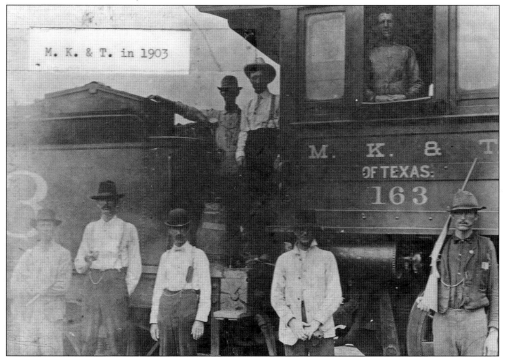

On the engine are, from left to right, fireman ? Kennedy, expressman J. Johnson, and engineer ? Hyson. On the ground stand are, from left to right, George Thomas, Pat Kelly, D. A. Kelly, ? Watkins, and ? Easley, toting a double-barrel shotgun. Although riding shotgun on a stagecoach carrying a payroll was standard practice in its day, the purpose of this guard or the shipment's contents are unknown.

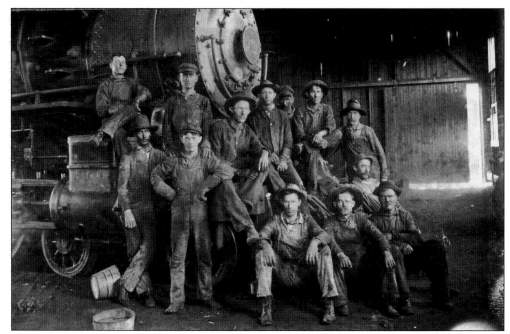

Around 1900, the more than 400 Katy (the nickname of the MK&T) workers included division superintendent, dispatchers, train masters, engine and train crew members, switchmen, express agents, and maintenance shop workers. A hostler worked in an engine shed under the operating foreman. He would pick up an engine from where the engineer left it running in the yard and move it into the roundhouse. The wiper worked in the roundhouse, packing engine parts with grease.

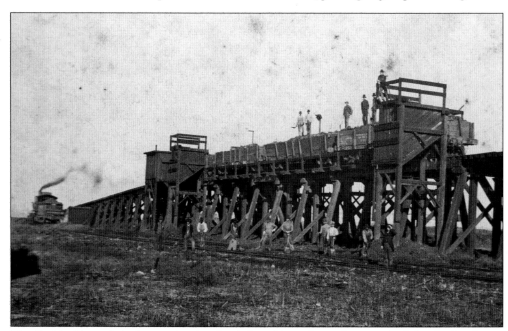

The Smithville coal tipple crew has just loaded coal into the coal car to the left, which is being pulled by a chugging steam engine. A tipple or trestle was used when locomotives pushed carts full of coal to the bunker and unloaded them into a hopper.

Formed by the freezing "Texas norther's" wind on February 13, 1905, icicles point slightly south around the bottom of the frozen water tank at the Katy rail yard. Four heavily clothed workers are dwarfed by the huge frozen structure. Fresh groundwater from the railroad's well was normally stored in the tank until thirsty steam engines stopped by to refill their depleted tanks.

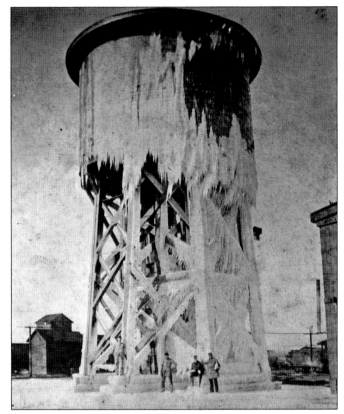

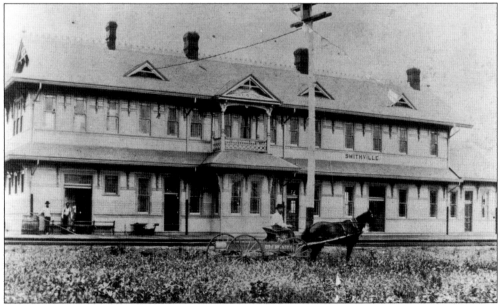

This second Smithville depot was built prior to December 1895 and burned down in 1908. It was located in between the two tracks that form a "Y" heading toward Lockhart and Bastrop. No pictures or descriptions exist of the first depot, which had been built in 1887. The third, and last, depot was built around 1909.

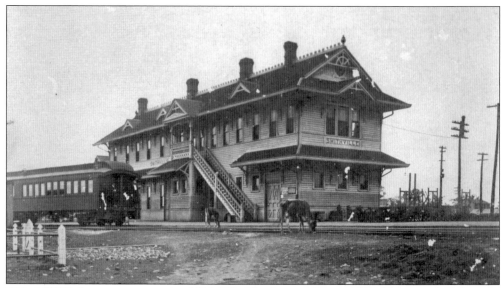

This MK&T depot cost upwards of $12,000. The large, substantial building was handsomely furnished, and the Western Union Telegraph office was upstairs. Trains and cows do not make a good combination, even in small country towns. Trains have used cowcatchers and pilots to deflect objects including cows from the tracks. Today fences keep most cows off the tracks.

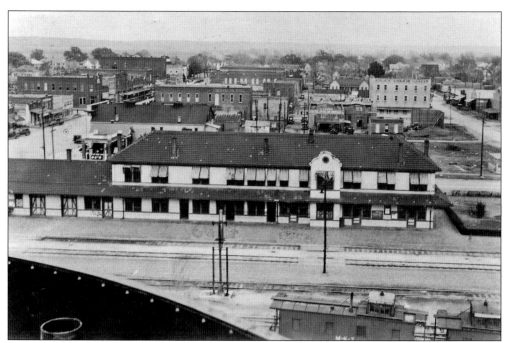

Smithville's third MK&T depot was built around 1909 and was located between First Street and the railroad tracks and between Main and Olive Streets. In addition to ticket office and baggage room, the depot housed the district superintendent's office, train master's office, waiting rooms, kitchen, and dining room. After the last passenger trains were gone, the depot was leased to private businesses until it burned in 1967.

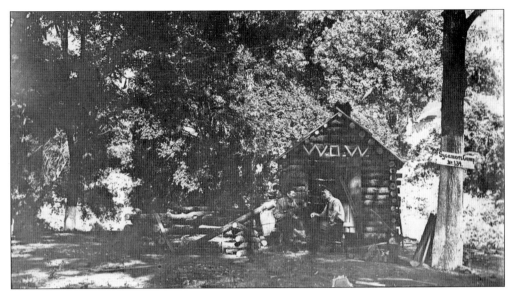

Woodmen of the World was founded in 1890 as a fraternal service organization to provide life insurance and other benefits to its members, who were encouraged to be active volunteers in their community. Many Smithville railroad workers were members of WOW, and their sons joined the associated Boys of Woodcraft clubs. These men are enjoying a WOW Campground at Riverside Park near Smithville.

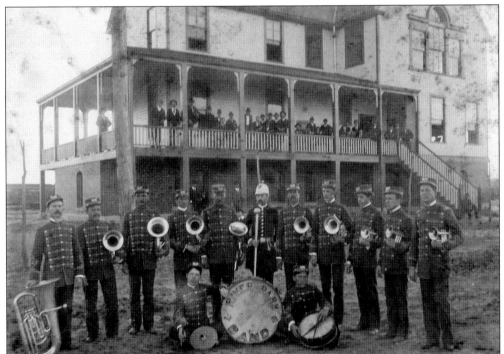

The River Park Band poses in front of the Railroad YMCA before the second-floor balcony was added around 1915. The community band was composed of 13 men playing mainly brass and percussion instruments. They entertained at picnics, especially on the banks of the Colorado River, and played at parties and other gatherings in Smithville during the late 1800s and early 1900s.

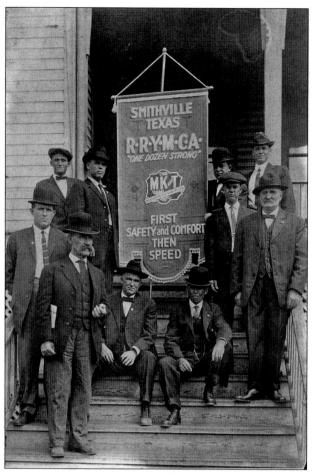

Surrounding a Smithville Railroad YMCA banner are Carl Cole, Tuck Reader, Allie Walker, Tom Jones, John Donovan, W. C. Dickson, and Messrs. Allen, Neely, and Roberts. The YMCA started Railroad YMCAs in 1872, soon after recognizing that men who constantly traveled in their work, such as railroad workers, were away from their familiar homes, churches, and families. These special-interest YMCAs started as reading rooms but grew to provide clean beds, good meals, and hot showers in facilities such as the Smithville YMCA, shown below. At the same time, they addressed educational, spiritual, and recreational needs of the transient railroad workers. During their peak, in the early part of the 1900s, there were well over 200 local associations. Because of changes in railroading, the associations dwindled in number through the 1930s and later. The Transportation Department of the YMCA finally disbanded completely in 1989.

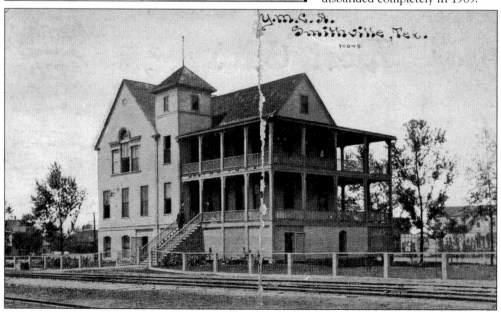

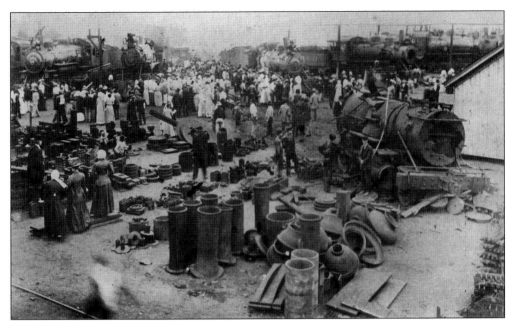

February 8, 1911, marks the worst and most widely reported accident in Smithville's railroad history, resulting in 11 men killed and another 9 injured. The boiler of one engine exploded, involving two other engines and blowing the firebox and cab into metal fragments, parts of which were found three to six blocks away. Explosion shocks were felt in Bastrop, 15 miles away. Pronounced dead were H. E. O'Rourke, C. W. Phelps, Harry Clark, Aaron Harless, Thurston McNeil, F. Barino, Charles Gray, Phil Hubbard, Allison Mitchell, Henry Stoglin and George Cook. Those injured were E. C. Rovillo, Charles Knopp, Harry Bank, William Bailey, R. A. Walker, J. A. Delap, B. C. Hodges, G. F. Petzinger, and George Behrens. Shown below is the memorial service for C. W. Phelps, complete with his Woodmen of the World memorial gravestone.

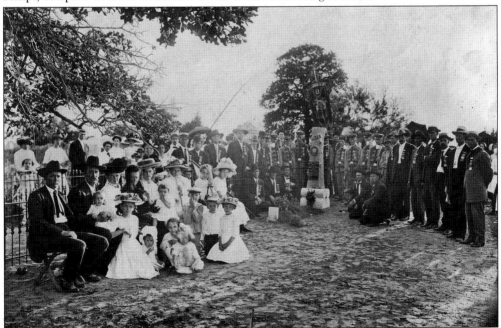

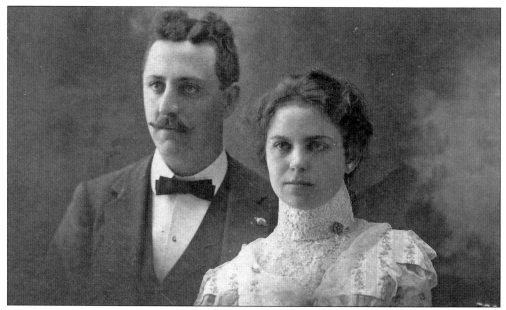

John Camp Yerger came to Bastrop County from Mississippi about 1850 and settled in the Hill's Prairie area. After the Civil War, he opened a mercantile store at Alum Creek with son-in-law John Walker Foster Hill, a member of Terry's Texas Rangers in the war. In 1887, after the railroad came, Yerger and Hill moved their store to Smithville and Yerger built the house below, one of the oldest in Smithville. Yerger started the Bank of Smithville, becoming its first president. The son of Hill and his wife, Mariah, Yerger Hill was born in 1869 on his father's ranch at Rocky Hill and after college became a partner in Yerger, Hill, and Son along with his father and grandfather. Yerger was one of the youngest successful businessmen in Smithville and often made trips east to buy merchandise for the store. He married Fannie Kinkle Harris (above), of Alabama, in 1900, and they had six children, all born in this home. (Above courtesy Sallie Skelley Blalock; below courtesy David L. Herrington.)

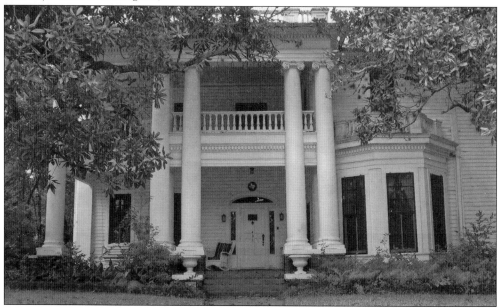

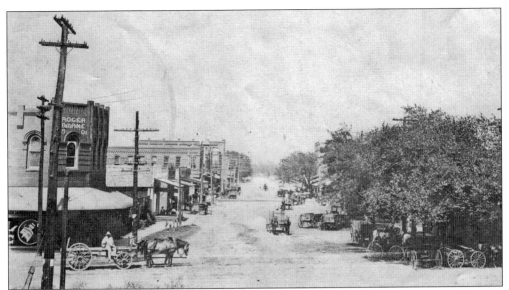

Looking north, horse-pulled buggies or wagons crowd along Main and First Streets. Wooden plank sidewalks are bustling with customers. The first Smithville village, built along the Colorado River several blocks away, moved here to meet the railroad. In tree-filled lots on the east (right) corner, the Star Theater, a Texaco station, and the Cactus Cafe would later become thriving businesses; and at left, Roger Byrne's saloon stands like a sentinel.

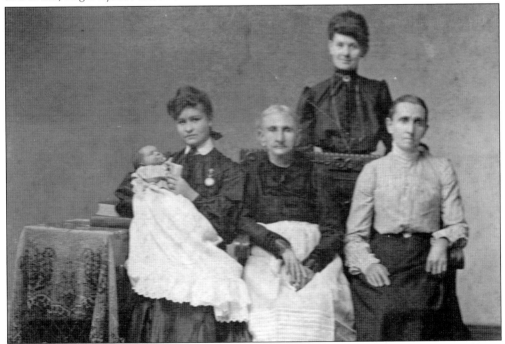

This 1904 five-generation photograph provides a varied insight into women's attire of these early years. Irene Tomlinson Bollier is seen with her mother, Dessie Mae Johnson Tomlinson Bollier; her grandmother, Eldora Johnson; her great-grandmother, Alwilda Bolt; and her great-great-grandmother, Phoebe Elwood; while she was visiting in Red Oak, Iowa. Such longevity, and the opportunity to all be together at once for a photograph, was a rather rare happening.

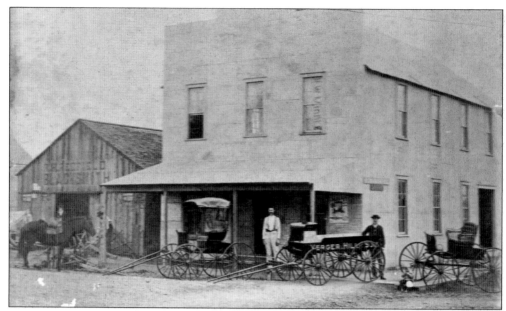

About 1894, Yerger, Hill, and Son's buggy has come to Middleton Blacksmith Shop at Second and Olive Streets to have work done or buy supplies, with Hugo Middleton and J. J. Middleton standing by and little Ned Reader sitting on the corner. The Middletons had bought their shop from John L. Hill and Albert Schober. Next door, a man has ridden his horse to do business with blacksmith R. H. Redfield here on "blacksmith row."

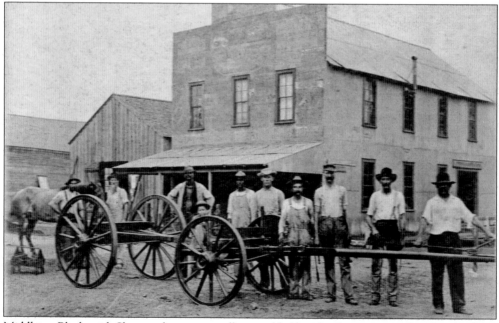

Middleton Blacksmith Shop workers are proudly assembled beside what appears to be a Luedinghaus wagon chassis around 1910, before Middleton's became the John Deere tractor and Studebaker trailer representative in the area. This location at Second and Olive Streets later became the location of the Herrington Motor Company, which held dealerships for Pontiac, Cadillac, and GMC vehicles; and today it is the home of Clarence's Refrigeration and Electric.

Since the late 1800s, the Smithville Volunteer Fire Department has been going strong. Attending a fire department dinner in dress uniform are, from left to right, (first row) Leah Powell, Hugo Middleton, and an unidentified woman; (second row) Mr. Moore, Henry W. Cook, Alfred F. Wotipka. Below, modern firefighters' silhouettes send an ominous message of danger, destruction, and despair as they fight this nighttime blaze. Brave men, and now women, respond to fires and other emergencies whether night or day, sunshine or rain, with 150 percent effort and smiling faces, and they are among the fastest responding units in the state. They train year-round to stay on top of their game and stay until the last smoke is extinguished or the last accident victim carried to a hospital via ambulance or helicopter. They do all this with no pay—all heroes in the finest sense of the word.

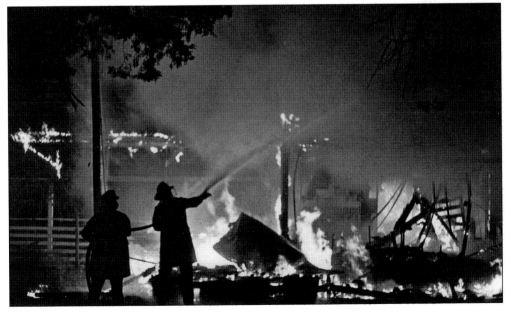

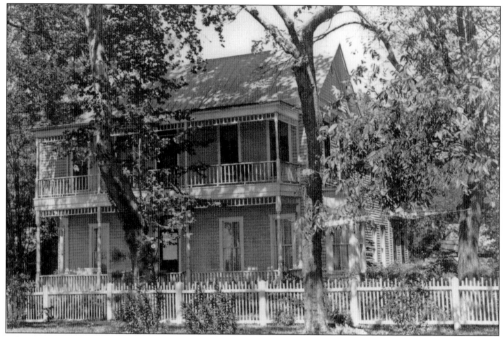

This lovely Queen Anne–style home on First Street near the railroad yard dates from the late 1800s. It was used in earlier years as a boardinghouse for railroad workers, and a legend floats around town about ghost sightings on the second floor of the house.

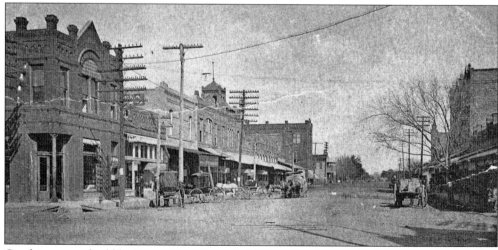

On this postcard sold by Searcy Drug Store in 1907, well before automobiles arrived, horse and buggies meander up the dirt road called Main Street. On the left corner is the Bank of Smithville, just before it became First State Bank, and in the middle of the block on the right is the Maney Opera House, in full operation in this pre-Prohibition year.

Kenneth H. McCaskill, born 1854 in Georgia, owned a blacksmith shop at Alum Creek and was one of the earliest families to move to the new Smithville across the river when the railroad came through. McCaskill married Elizabeth Gertrude Collier and had at least one son. He owned several pieces of downtown property when he died in 1931, including the McCaskill building at Main and Second Streets.

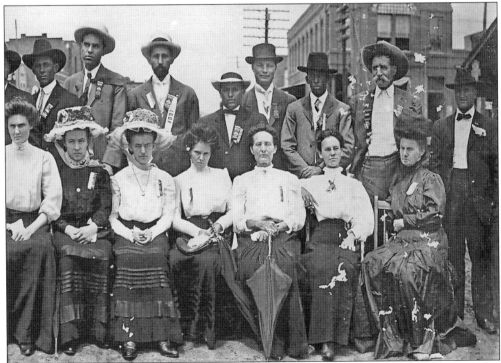

Organized in 1895, the Independent Order of Odd Fellows bought the second floor of the building at the southeast corner of Second and Main Streets from the Masonic Lodge. In Silky Crockett's book, she describes the recently remodeled meeting hall and recreation room upstairs. The Odd Fellows met in this building until 1985. The Bank of Smithville in the back corner dates this picture between 1903 and 1907.

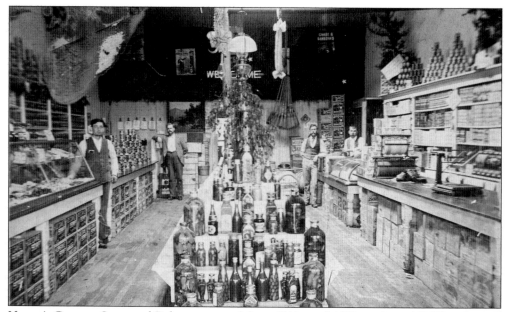

Hoppe's Grocery Store and Bakery operated from 1911 until 1922 at about 117 West Second Street, near the corner of Ramona Street. They were known for their delicious bread delivered in a horse-drawn wagon. After 1915, Hoppe's was only a bakery.

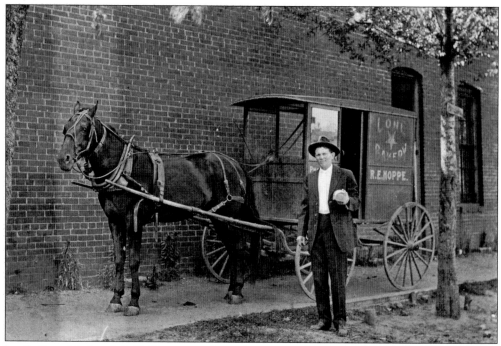

Loaf of bread in hand, R. E. Hoppe stands ready in suit and hat beside his delivery wagon full of freshly baked goods, while his faithful horse calmly awaits the start of the day's delivery route. Customer Hazel Lovelace said, "The bread was delicious and you didn't have to worry about the germs."

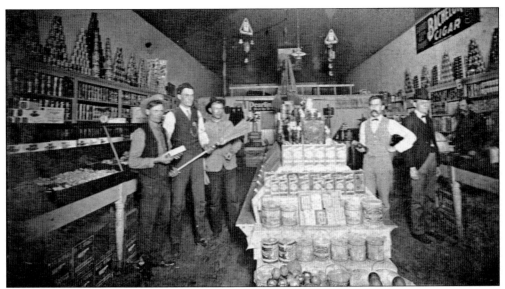

From the mid-1900s through about 1930, John Haynie ran Haynie's Grocery and Dry Good Store in the Masonic building at 301 Main Street. Shopping in Haynie's was effortless, since patrons just gave their order to the clerk and he would get everything for them.

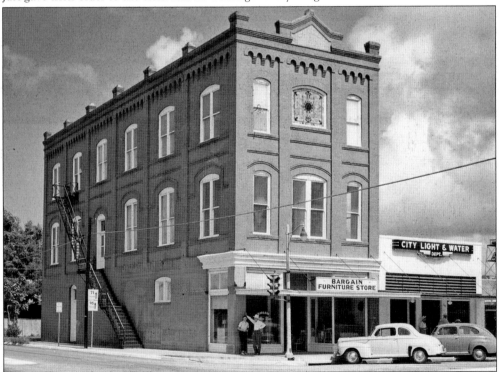

The Masonic building, constructed in 1903 to be used as a lodge on the third floor, has housed many businesses, including Haynie's Grocery, the Bargain Furniture store, artists' studios, a clothing manufacturer, and restaurants. For many years it was the tallest building in Bastrop County, the upper two floors are now used as private apartments, as are several other upper floors in Main Street buildings.

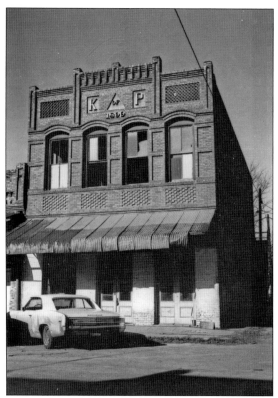

The Knights of Pythias Lodge bought the upper story of Eagleston's two-story brick structure on east Second Street. The edifice, now gone, was listed on the National Register of Historic Places. The lodge practiced friendship, charity, benevolence, and "Peace Through Understanding." Originally created by an act of Congress in 1864, the Knights endeavored to heal the wounds and hatred caused by the Civil War.

The *Smithville Times* ran an article in 1917 that headlined, "White Sox vs. Smithville." As unlikely as it seems, the Chicago White Sox regular team played Smithville Katy Athletic Association Nine, a team made up of railroad men, on March 23, 1917, for a crowd of about 850 fans. The game was described as "interesting and well played." Some of the players may have also been in this 1913 team picture. Who won? The Sox defeated the Katy boys, of course, 9-1.

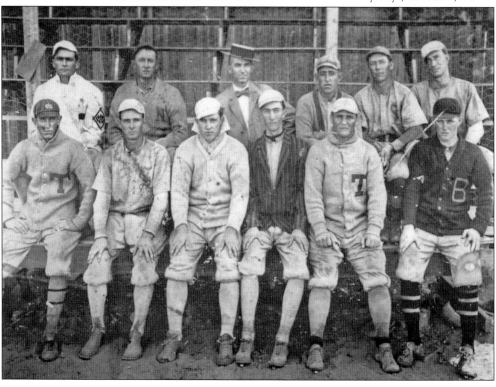

Young Thomas sits between his parents, Mariah Holland Aldridge Smith and Thomas Jefferson Smith Sr., as sisters Alice Madora (left) and Mattie J. (center) stand with brother William John (right). In later life, Dr. Thomas Jefferson Smith Jr., DDS, moved to Smithville and practiced dentistry from about 1914 until 1949. Dr. Smith's office overlooked Second and Main Streets from the upper floor of the Bank of Smithville Building. (Courtesy Dorothy Barton.)

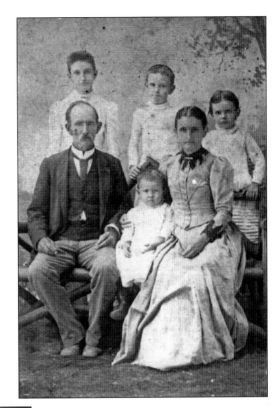

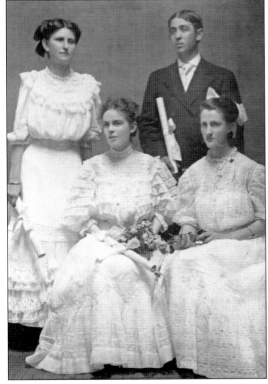

Honor students Mabel Saunders and Mildred Goskill join Alice Steffens, valedictorian, and Leslie Gilbert, salutatorian, their 1907 graduating classmates. Colonel Gilbert, as he would later be known, successfully and honorably completed a military career that began at Texas A&M University and encompassed both World Wars I and II.

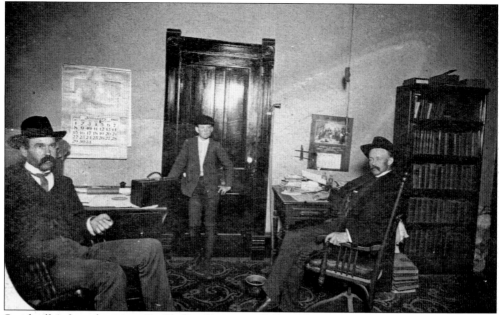

Smithville's first physician, Dr. Phillip Chapman (left), a Tennessee native, came to town about 1903 and by 1922 was mayor. In 1905, he visits with young Jack Powell and his father, Dr. John Henry Ericsson Powell, a Virginia native who arrived in 1880. In addition to his medical expertise, Powell was significant in Smithville's early business development, eventually becoming involved in cotton gin, drugstore, banking, and real estate enterprises.

Rachel Jones Powell, born in 1865 to Benjamin F. Jones, married Dr. J. H. E. Powell in 1885. Before the railroad came and Smithville became an incorporated town, she went on rounds and assisted Dr. Powell, especially with obstetrical cases. They had five children: Leah, Jack, Frank, Will, and George. Leah died in 1908, killed in a runaway horse and carriage accident, which affected Rachel until her death in 1958.

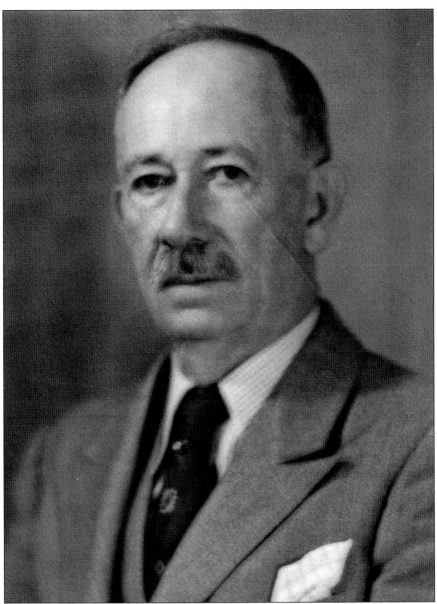

Recognizing the future of building in a growing Smithville, in 1891, Virgil Sullivan Rabb Sr. of West Point purchased Austin-based Calcasieu Lumber Company's Smithville store. He continued to run his lumber business in nearby West Point, while son Virgil S. Rabb Jr., pictured here, began to lead the Smithville lumber yard in the spring of 1894. Virgil Jr. turned out to be a prolific builder thanks to his innovative idea of constructing houses using few floor plans, precut lumber, and pre-ordered hardware and buying massive quantities at discounted prices, passed along to customers. Many historic homes were built by Rabb in the original Smithville town site, the Burleson addition, and on Mount Pleasant (the Hill), fashioned in Queen Anne, Folk Victorian, and neoclassical styles popular around the turn of the 20th century. In 1907, Rabb and his father-in-law J. H. McCollum constructed a large, red-brick building at 300 Main Street for their combined furniture and dry goods business. For his family, he built a large Queen Anne–style home on the Colorado River, now on the National Register of Historic Places.

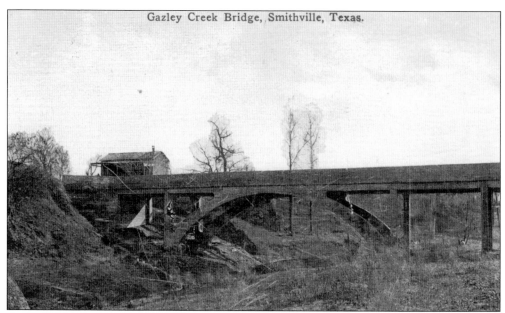

Gazley Creek Bridge, Smithville, Texas.

Gazley Creek, west of the rail yard, required a trestle to allow the rail line to follow the flat country west of the Colorado on its way around Copperus Hill into Bastrop. This 1900s structure was a striking deviation from typical pile-driven wooden trestles, as it displayed an advanced architectural design that was more pleasing to the eye. Unfortunately, in 1940, Dr. Gazley's creek washed it out during a rainstorm.

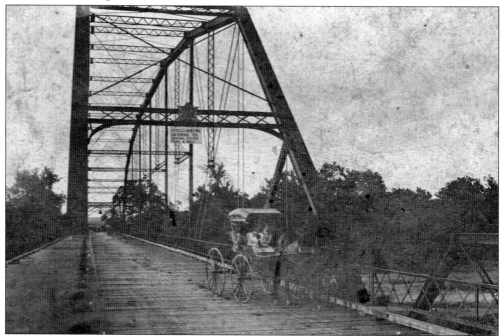

Two young ladies ride a horse and buggy over the first Smithville bridge across the Colorado River. Built in 1900 at the end of Main Street to replace the ferry that had operated since 1888, this iron bridge consisted of a Parker truss center span on two sets of concrete piers braced with wooden planks, with a wood plank roadway. This bridge lasted until the great flood of 1913.

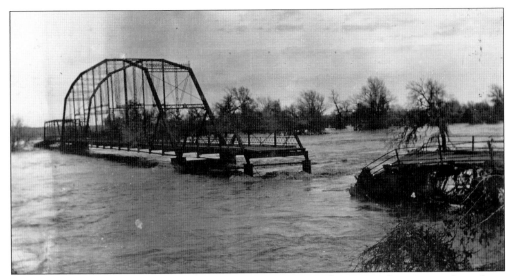

Smithville, a typical river town, has witnessed extreme conditions on the river, such as those shown in this shot of the first break in the collapsing Colorado River Bridge during the December 8, 1913, flood. The impact both of flooding and drought lessened after the Lower Colorado River Authority (LCRA) was created in 1934 to harness the river, building regular and hydroelectric dams that help to control the flow of water while producing electricity.

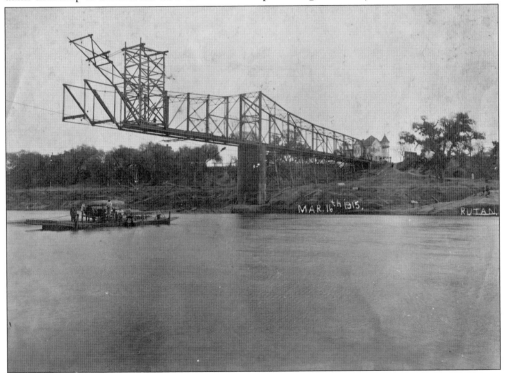

This March 16, 1915, bridge construction photograph exhibits the latest in bridge-building technique. This replacement for the structure destroyed in the 1913 flood carefully cantilevers across the Colorado River, spanning north from the town side. A similar segment of the bridge approaches from the opposite riverbank to ultimately link at mid-span.

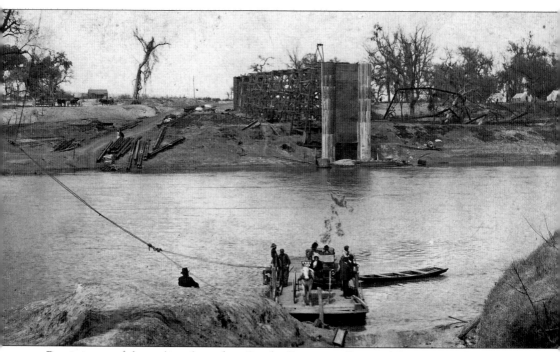

Reminiscent of the earliest days when Smithville was a village and ferries carried cotton across the Colorado River to the Smithville Gin, this ferry was used to transport vehicles after the flooding of the first bridge in 1913 and before the completion of the 1915 Colorado River Bridge. Four ferry operators were permitted to operate in early Smithville: J. S. Burleson in 1870 at Shipp's Plantation; B. F. Hudgins in 1881 at Shipp and Nichols's place; a barge-type ferry operated by the Smithville Ferry Company in 1888, owned by K. H. McCaskill, Murray Burleson, and Robert L. Nichols, which crossed the Colorado opposite the end of Main Street to the end of Royston Street; and finally the Smithville Ferry, run by J. L. Scroggins in 1890, which he operated until the first bridge was built in 1900.

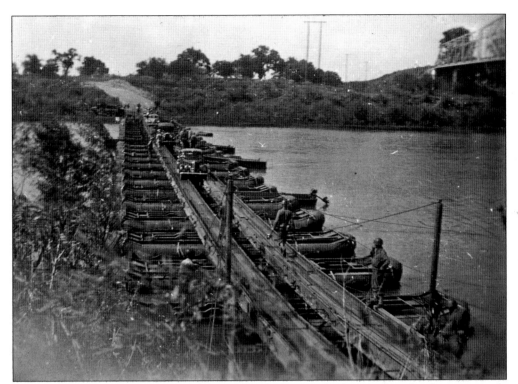

In the mid-1940s, having survived the 1935 flood, the river bridge was forced to be temporarily closed as a result of structural impairment caused by a military bulldozer being transported across it. Since there was no other bridge between La Grange and Bastrop, the Army Corps of Engineers quickly assembled a floating pontoon bridge just upstream to handle the vehicular traffic. Townsfolk held picnics and watched the construction from the riverbank.

Historically, traffic through Smithville followed the north half of Main Street from the river bridge to Third Street and turned either east or west. Service stations were a highlight of this corridor: Texaco, Gulf, Sinclair, and so on. These service facilities washed the windshield; whisked the floors; checked the oil, water, and battery; and provided comfort facilities for patrons while they filled the gas tanks, all for only two bits a gallon.

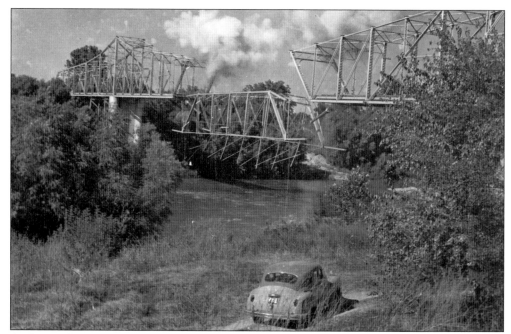

By September 8, 1950, the 1915 Colorado River overhead box girder bridge had fulfilled its intended purpose. Capturing another moment of the city's history, Fred Moree, Smithville's noted photographer, caught the center span of the bridge in a midair free fall immediately after demolition charges were detonated to bring down the obsolete and damaged structure. Subsequent bridges have served the city from other locations.

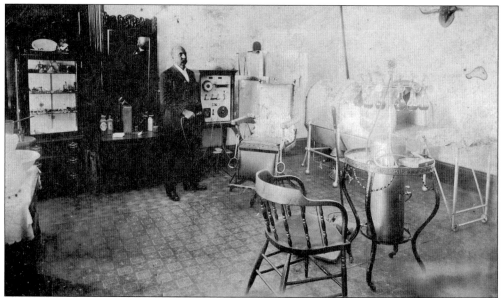

After getting cash at the Bank of Smithville, ailing Smithvillians could visit Dr. J. W. V. Hickman's Physiological Therapeutics Laboratory, which advertised the latest in electrical equipment, X-ray, and medical gadgetry. He could locate bullets, stones, and broken or dislocated bones; examine and treat rheumatism, cancer, and women's diseases; treat piles and fistulas without surgery; remove freckles, moles, warts, and tans; promote hair growth; and cure dandruff.

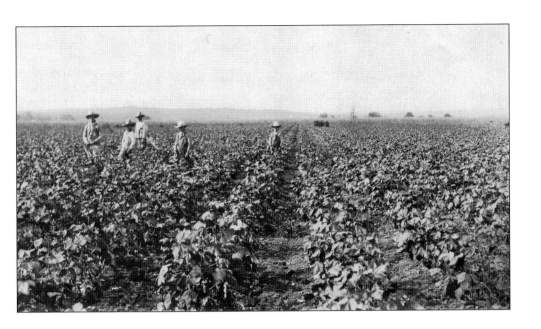

Cotton was for many years a vital business in Bastrop County and the premier industry in Texas. Although Bastrop was not a leading county for cotton production, cotton was one of the biggest crops produced for many years. Until the Civil War, African American slaves provided most of the labor. Afterward, tenant farming became the predominant means of securing labor. Usually the whole family worked in the fields picking cotton, until mechanized equipment came to the rescue. Smithville Gin Company, owned by Henry W. Cook, Emil Buescher, Dr. J. H. E. Powell, and Edward H. Eagleston, operated from 1891 to about 1983 and was torn down in 1995 to build a city recreation center. The conveyer shown below carried cotton seed from the gin to the Smithville Cotton Seed Oil Mill.

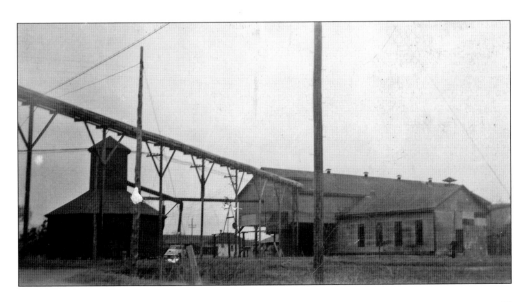

The Smithville Oil Mill was on Royston Street (Highway 95) at the northwest corner of Second Street, and as long as the cotton gin across the street was in operation, it was connected to the gin via a conveyor belt that went across Royston. Cottonseed oil is made from crushed cotton kernels, after hulls have been separated for livestock feed and linters, or long fibers, have been ginned.

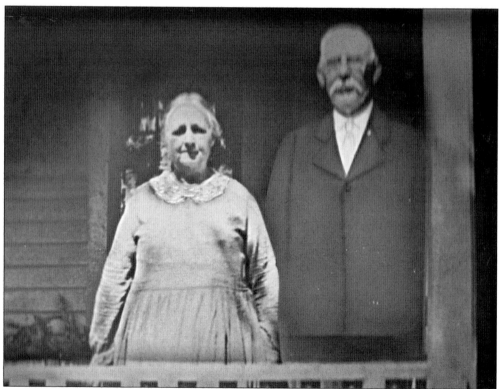

On the front porch of their home on Second and Fawcett Streets, right behind the cotton gin, pose Henry William and Josephine Vogelsang Cook, both born to first-generation German immigrants. Cook lost his left hand working at Smithville Gin Company, which he co-owned with Emil Buescher, Dr. J. H. E. Powell, and Edward Eagleston. He was a member of city council and served as an officer in the First Presbyterian Church. (Courtesy Dorothy Cook.)

Emil Buescher came to Smithville in 1897 with brothers Hugo and Oswald, all sons of G. Buescher in Moulton, and contributed immeasurably to the town's infrastructure in the years that followed. Almost as soon as they arrived here, the brothers started the first light and water system in the town. Buescher built Smithville Oil Mill in 1900 and organized city sewage in 1903. In 1904, Buescher, Eagleston, and Dr. Powell started a new private school known as Smithville Academy, which was open for just a few years. Buescher bought an interest in the Smithville Gin Company in 1907, joining Eagleston, Powell, and Henry Cook. That year, he also became a stockholder in the newly formed First State Bank. In 1915, he brought picture shows to Smithville. He was president of the school board for a number of years and was very active in the Presbyterian church.

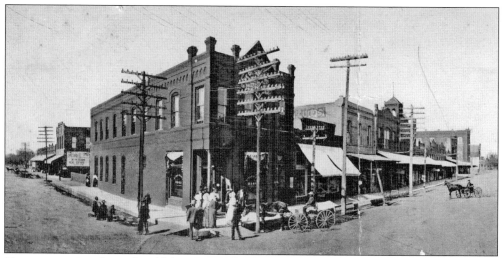

Customers wait at Second and Main Streets for the First State Bank to open, as horse and buggy traffic signals the start of another business day. There are electric utility lines on Smithville streets, even in the early 1900s, and ramps from the dirt streets to the sidewalk, well before the American Disabilities Act. Ladies still wear bonnets popular at the dawn of the 20th century. The Knights of Pythias building is to the left, west on Second Street.

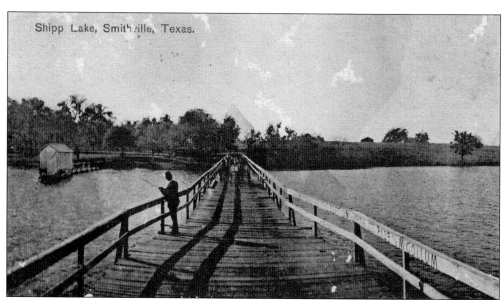

This postcard photograph depicts the wooden bridge that once crossed Shipp's Lake east of town. A derby-hatted man fishes from the bridge, while in the background, pedestrians and a horse and buggy cross the rickety-looking bridge. An advertisement for Rabb and McCollum Land Company, which specialized in real estate and loans, is painted on the right-hand inside railing, indicating the picture was taken around 1910–1915.

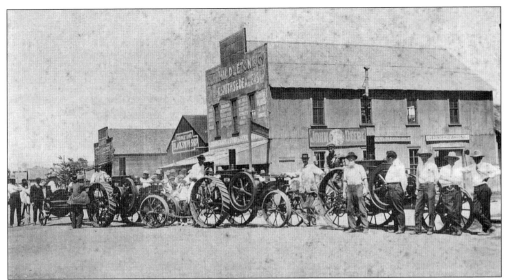

Middleton's Blacksmiths and Dealers Establishment sold John Deere plows, Luedinghaus and Studebaker wagons, McCormick (International Harvester) Mogul tractors, and other farm-related products. Here they take delivery of the first three 1916 model 8/16 single-cylinder gasoline- (petrol) and kerosene-fueled tractors to arrive in Smithville. Potential buyers and interested onlookers gather to inspect the new agricultural technology.

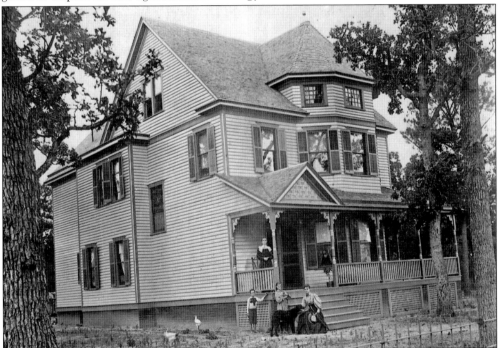

Chester Hart Turney's large house on the hill, pictured here with some of his family, burned in the 1930s. In 1894, when the MK&T brought their maintenance shops to Smithville, the Turney family moved here from Taylor. Subsequently, he opened a large lumber yard and a brickyard up on the hill. Turney led the successful fight in 1922 against the MK&T to keep them from removing Smithville's terminal.

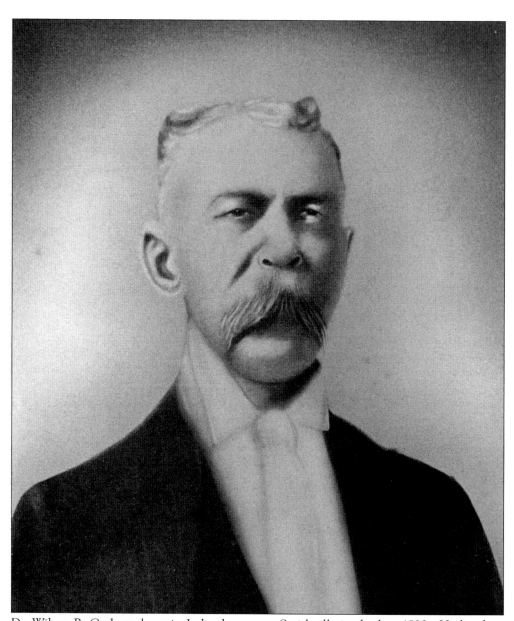

Dr. Wilson R. Curham, born in Ireland, came to Smithville in the late 1890s. He lived on "Doctors Row" in the 200 block of Ramona Street, along with Dr. J. D. Stephens and Dr. J. H. E. Powell, and his office was at 115 Main Street. He was mayor of Smithville from 1914 to 1922, presiding over the building of a new city hall in 1916. In 1917, on City of Smithville letterhead, Curham wrote a letter to Gov. James E. "Pa" Ferguson, offering to organize a company of the new National Guard in Smithville for World War I. "I prefer fighting to practicing medicine," he argued. Indeed, his history supported that, since he had fought in the Sudan Campaign in Egypt in 1893–1898, before he was 21, and then went directly into the Spanish-American War, fighting under well-respected Gen. John A. Hulen. In 1918, during the influenza outbreak, he announced the banning of assemblies in Smithville. He served as surgeon for the MK&T Railroad and as Smithville health officer and was said to have delivered "thousands of babies" in this county before his death in November 1941.

By the 1930s, when this picture was taken, Roger Byrne had served Smithville and Bastrop County as mayor, representative to the state legislature for 12 years, fire chief, president of the State Firemen's Association, saloon owner, farmer, banker, real estate mogul, and philanthropist. Byrne was born in County Donegal, Ireland, in 1858 and immigrated to the United States in 1873. He made his living as a linen salesman, who drove a buggy around the country selling his wares, before he arrived in Smithville about 1894. Byrne purchased the saloon building on the then Front Street (now First Street) in 1897 from B. J. Gresham, and in 1903, he helped organize the First National Bank of Smithville on Second Street. Byrne became president by 1916, and in 1920, the bank moved to Main Street. Eventually, the bank failed, as did many others during those years. Byrne donated the rose window at St. Paul the Apostle Catholic Church and often entertained in his home.

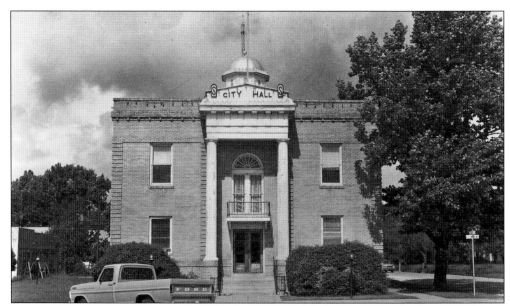

The second city hall was built by E. E. Emory for $7,900 and completed in December 1916. It was demolished October 14, 1968, making way for the current city hall. The first city hall had been built in 1896 by C. M. Smith at a cost of $1,530 and was on land purchased for $550 from Smithville Town Company on the west side of Olive Street in the 200 block.

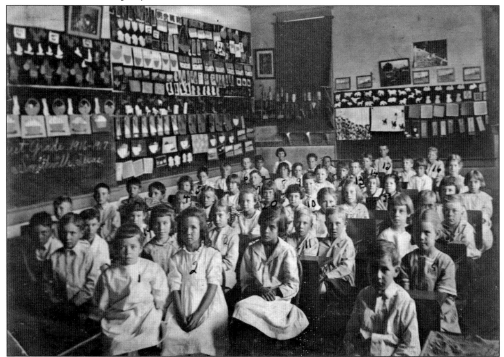

This picture of the first grade of 1916–1917 was taken in their school room in Central School on Gresham Street. This building was used as an elementary school until 1973. Familiar Smithville names in this picture include Winston, Miller, Eagleston, Patterson, Stiteler, Saunders, Hawkins, Delaney, and Wotipka.

Three

WAR AND
DEPRESSION YEARS

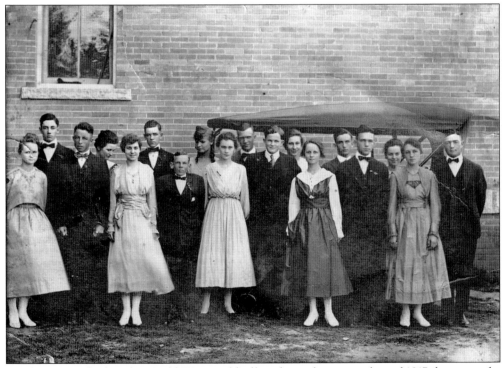

Not knowing whether the World War would affect them, the senior class of 1917 dresses up for prom night. The group includes, from left to right, Lorene Barry, Houston Parrott, Dowell H. Nichols, Ruth Saunders, Anna Bell Searcy, Wilkes Cox, Dorsey Haynie, Virgie Moncure, Fern Birch, "Ty" Ronald Renick, George Powell, Erna Stoerman, Anna Lena Winston, Raymond House, Mike DeWitt Maney, Dorothy Kemp, Jewel Engle, and Neil ?.

On December 6, 1917, in this building once known as the Star Theater, Margaret Woodrow Wilson, oldest daughter of Pres. Woodrow Wilson, presented a World War I benefit concert, one of many she performed all over the United States. In Smithville, her ability to draw a capacity crowd ensured that nearly $1,200 was raised for the fund before she left for her next stop in New Orleans.

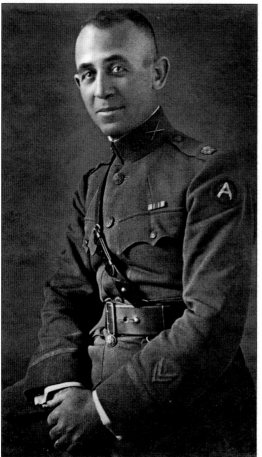

Col. Clarence Leslie Gilbert, born in 1890 in Smithville, graduated with honors from Texas A&M University. In 1912, he joined the army's Coast Artillery Corps, where he rose rapidly through the ranks during World War I. Speaking fluent German and French, Gilbert served in the Army of Occupation in Germany. He had special assignments in World War II, then retired to Smithville, where he spent many happy years until age 99.

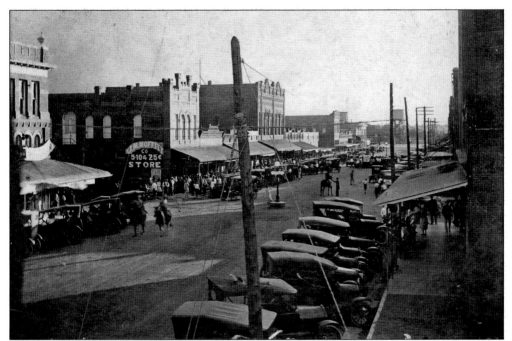

In the early 1920s, before Main Street was paved, there were light posts in the middle of intersections. Men on horseback and even horse and buggies could still be seen, although the streets were filled with Model Ts. In this picture, J. M. Moffitt's 5-10-25¢ store was on the southeast corner of Third and Main Streets, and in the same block, the Maney Opera House was still standing.

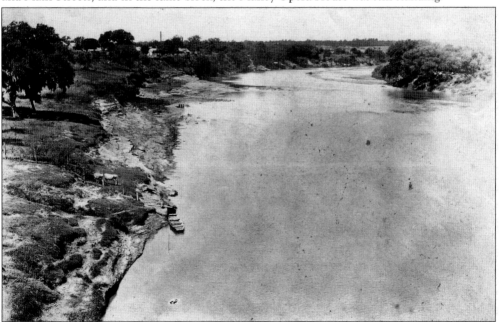

A historic view, from an early Colorado River bridge looking upstream to the west, reveals this fishing boat moored near the point where the old ferry once crossed the river, and just at the foot of the sloping area where an emergency pontoon bridge would later be assembled to allow traffic to cross the river and enter the town, winding uphill between the mighty oak trees.

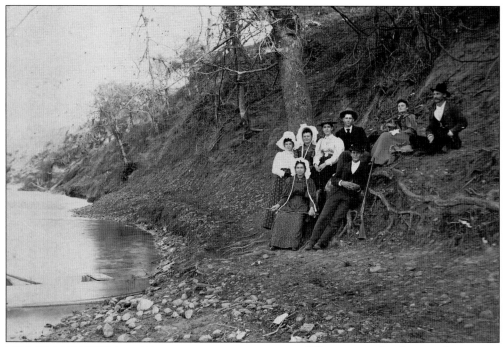

When not at flood stage, the Colorado River has always served as a recreation area for Smithville. In the 1920s, young men and women gathered to hear the River Park Band play for picnics, to go swimming or boating, or just to stroll and visit with their friends along the banks of the river.

Oliver Winston, pictured in the early 1920s, received a bachelor of arts and a bachelor of science degree in architecture from Rice Institute and was a consulting architect on Houston's landmark River Oaks Community Shopping Center in 1936–1937. He served as regional director of the U.S. Housing Authority in Washington from 1939 to 1947; in planning positions in Binghamton, New York, and Baltimore, Maryland; and in the Office of Regional Resources and Development at Cornell University.

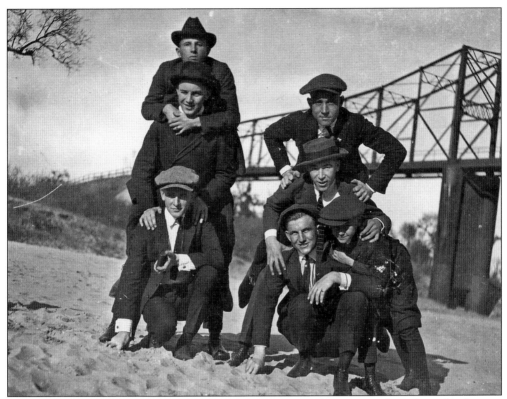

"Kodaking" with friends was a popular pastime in the early 1900s, either after school or on weekends. The camera caught some of the biggest athletes, including Harold Mortimer, Travis Dickson, Cleve Stover, Homer Stevens, Vernon Wilson, and Dutch Flory, as they were horsing around near the second Colorado River bridge at the end of Main Street. Below, found picnicking at Maney's Sandbar on the river, is a group, which includes Elizabeth Reck, Frances Wadley, Perry Putman, Ruby Hewett, Armede Ingle, Homer Stevens, and others. This group comprised most of the graduating class of 1922. The high school was still housed in Central School; the "new" high school was not built until 1924. The "newer" high school was built in 1985 and the "newest" in 2003.

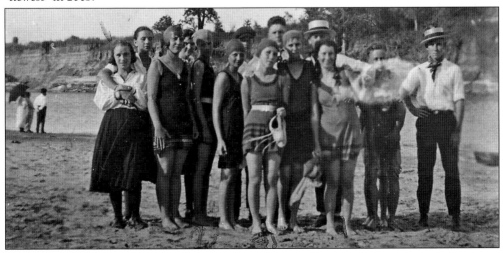

"Old Deestrict Skule"

WILL "TAKE UP BOOKS" AT 8:00 P. M.,

Friday Night, January 27th, '22

—AT THE—

MANEY OPERA HOUSE

* * * * * * *

THE PEOPLE WHO WILL MAKE YOU LAUGH:—

Professor Ezekiel Simpkins Mr. W. W. Dees.
Deacon Tidd Mr. R. C. Campbell
Mrs. Amanda Jerusha Quackenbush .. Mrs. W. H. Tolbert
Charity Webster Mrs. C. E. Mortimer
Liza Ann Snodgrass (The rich man's daughter)
...................... Mrs. F. R. Davis.
Tooty — The Bradshaw Twins .. Mrs. L. W. Warenskjold
Frooty — The Bradshaw Twins Mrs. G. J. Hill
Peruna Jones Mrs. W. F. Whittaker
Patience Puddifoot Mrs. H. E. Dain
Mehitable Honswoggle Mrs. O. Davis
Semanthy Small (The fat girl) Mrs. R. C. Campbell
Lydia Pinkham Mrs. R. A. Sawyer
John Jacob Astor B. G. Whitlow
Brigham Young Joe Stubbeman
Ben Butler R. O. Calloway
Buster Brown W. C. Miller
Cornelius Vanderbilt Frank Stasny
Jim Blaine C. J. Peel
Christopher Columbus A. P. Lowrey
Petey Barnum C. E. Mortimer
Jesse James Clarence Hemphill

Miss Reese who is arranging for American Legion Home
Talent to be given later will give the reading
"20 Years Ago," between acts.

* * * * * * *

"The All-Star Chorus" composed of Misses Anderson,
Robertson, Chalk, Nichols, Campbell, Rambo, Snow, Steffens, Collins, Stover, Alexander and Harmon in popular
numbers between acts.

Miss Osborne — Accompanist.

"Old Deestrict Skule," held in the Maney Opera House on January 27, 1922, was apparently a satire, with characters such as Lydia Pinkham, John Jacob Astor, Brigham Young, Buster Brown, Cornelia Vanderbilt, Christopher Columbus, and Jesse James—all familiar names on this date in history. Many of the actors' names can be found in early railroad records as engineers, brakemen, or firemen.

On September 13, 1923, a group of men came to examine the biplane used by MK&T to promote its Texas railroad business: the "Katy Flyer," the "Texas Special," and the "Bluebonnet." They also used special railroad cars to promote the business. The biplane, possibly the same plane flown over Waco by C. W. "Whit" Turney as a feature of the big Katy-Kiwanis event there, bore the inscription "Waco, Katy Flyer, Kiwanis." The MK&T also had special railroad cars to promote the Texas trains.

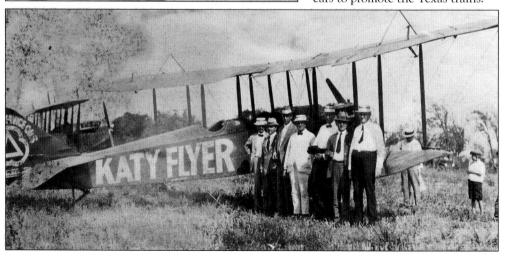

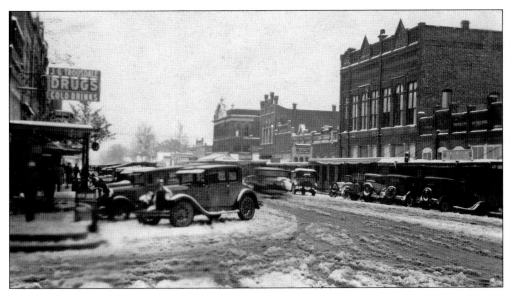

A very rare snow for this part of Central Texas fell on Main Street in the mid-1920s. Notice the Model Ts, which brought people downtown to do business and to shop. Maney Opera House, the large two-story building on the right, was constructed in 1893 but burned down around 1928. The opera house and Shade's Saloon on the first floor closed down in 1919, when Prohibition became law.

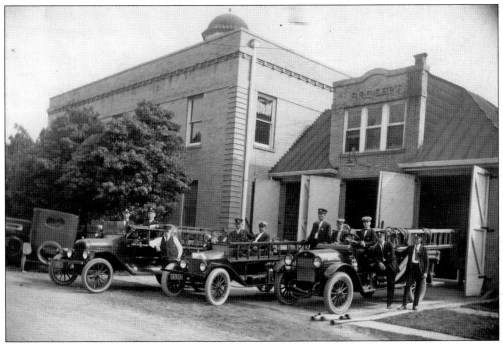

William Stoermer, Leon Brube, E. Clay Finch, and other firemen exhibit the newest in 1920s firefighting equipment, with Model Ts parked alongside city hall. Neither the old firehouse nor the old city hall exist today, and the cupola shown in city hall's roof now serves as the gazebo roof at Railroad Park. Smithville's Volunteer Fire Department has been vital to its public safety since the late 1800s.

The March 1927 presentation of *The Stolen Flower Queen*, staged by students of Central School, earned receipts of $176.20, more than had ever been made by a performance in the school auditorium. Silky Ragsdale Crockett, local author and historian, seen as attendant Moon-Beam (fourth from left in back row), still recalls the production as being a memorable event, starring Jo Hilary Ingram as the Fairy Queen.

About 1928, at Janak Motor Company's Whippett-Willys-Knight dealership on East Second Street, an assembly of spectators watches what might be a radio broadcast by the gentleman at center with the old microphone. Whippett and Knight luxury touring cars were short-lived thanks to the Depression; but the Willys Jeep, the forerunner of the modern military Humvee vehicle, became the World War II mainstay of small military vehicles and is still in production.

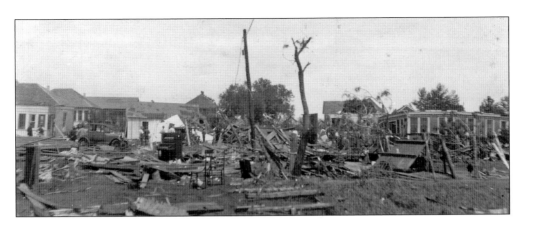

Until April 24, 1929, Smithville was considered to be just on the edge of "tornado alley." Unexpectedly, a devastating twister came to town that day and leveled a portion of the city. The above photograph depicts graphic evidence of the storm's high winds and destructive power. The hopelessly entangled jumble of what had once been a house, the leafless tree, the damaged upright piano, and the strewn possessions are all that remain of this former proud home. The photograph below shows the selective nature of the storm's damage as this house and its roof withstood the tornado's force, yet wind-blown objects laid waste to the automobile in the front yard, which no longer has windows or headlights. Several citizens were injured, but fortunately no one was killed; the city's damage was estimated to be $60,000.

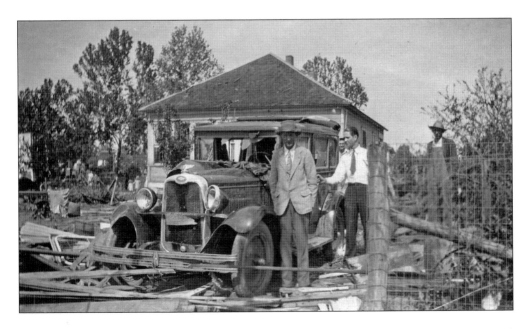

Far superior to a dip in the Colorado River at Maney's Sandbar, Lakeside Park afforded a spinning top in the mid-depths of its artesian water to amuse and cool off area swimmers. Its three-level diving tower provided sufficient heights for the most accomplished divers. A fishing marina, rental cabins, tavern, hunting lodge, and roping arena rounded out the available recreational opportunities at Shipp's Lake east of town.

The 1935 Tiger lineup included senior Lewis Berry (first row, far left) and science instructor and head coach Harry Stiteler (second row, far left). Stiteler later became head football coach at Texas A&M University. Lewis Berry, North Texas State Teachers College chemistry graduate, was chosen by the U.S. government to work in the development and testing of the Trinity atomic bomb used to conclude World War II.

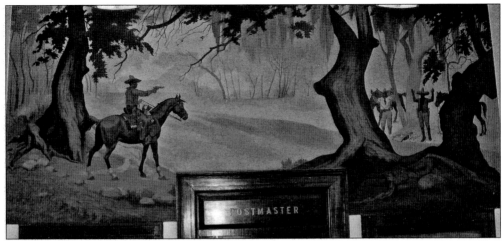

A result of Pres. Franklin Roosevelt's New Deal program, the Smithville Post Office, built in 1937–1938, was selected to receive a painted mural. Minette Teichmueller of La Grange, in her 60s, was one of only six women chosen to paint a Texas post office mural. Smithville's mural is titled *The Law—Texas Rangers* and depicts a lone Texas Ranger apprehending a band of desperadoes. (Courtesy David L. Herrington.)

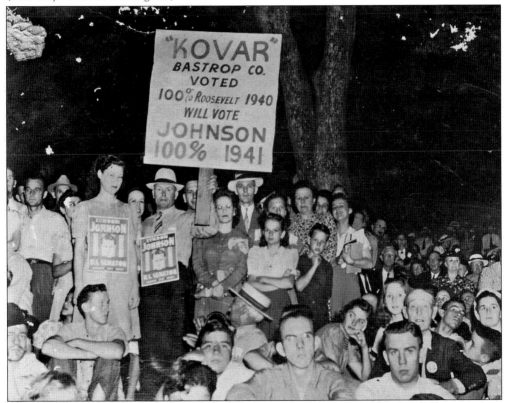

Until the late 1900s, Bastrop County was well known as a solid Democratic voting region. As if to echo that fact, and to project future voting outcomes, folks from the Kovar community south of Smithville held a rally and displayed signs supportive of 100 percent voting effectiveness for early 1940–1941 elections. Franklin Roosevelt and Lyndon Johnson truly had their votes of confidence.

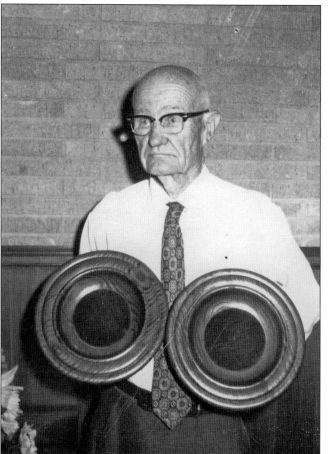

The oldest grave recorded in Oak Hill Cemetery is of John Mounger, buried in 1891, with about 15 more people buried there in the 1890s. Military graves in the cemetery include those from the Confederate army, Spanish-American War, World Wars I and II, Korea, and Vietnam. Oak Hill was originally deeded to the Smithville Cemetery Association, which in turn transferred it to the City of Smithville in 1936. (Courtesy David L. Herrington.)

The First Presbyterian Church collection plates that John J. Stalmach is holding in this undated photograph were handmade by him out of wood from the old J. Nixon Masonic Lodge building at Pea Ridge and are still in use today. The lodge was built in 1875 and used until 1888, when they moved into Smithville.

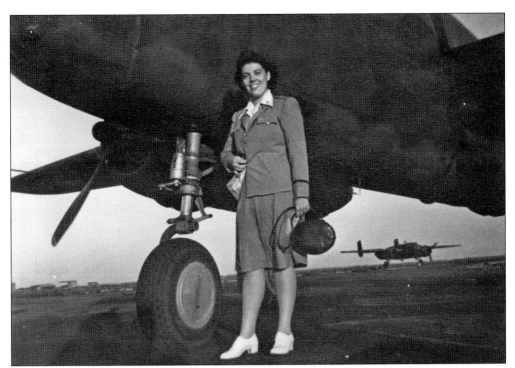

World War II saw young Smithville women like Leah Edwards serve in the military alongside men in the defense of their country. Having graduated from Thomas Jefferson Hospital School of Nursing in Philadelphia, Pennsylvania, Second Lieutenant Edwards proudly served the Army Nurse Corps in Cairo, Egypt; Benghazi, Libya; Bezerte, Tunis; Alghero, Sardinia; and Lyon, France.

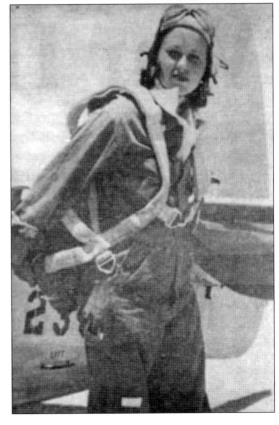

Grace Rosanky Putnam Jones graduated from Smithville High and entered Baylor University at age 15. She left Baylor during World War II to learn flying and join the WASPs. After the war, she became a model and television commercial personality, finally opening a couture fashion shop in artsy Salado, Texas, where she brought in top designers from the fashion world. She died in February 2008.

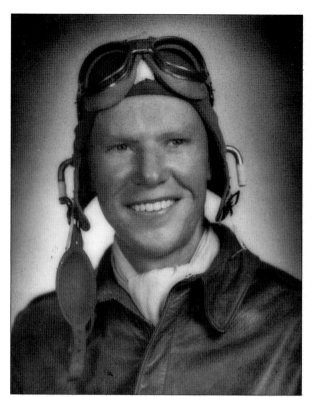

Young Floyd R. "Skip" Hyson, here in flight gear, flew for the air force during World War II, the Korean War, and Vietnam and was promoted to lieutenant colonel before retiring. Back home in Smithville, Skip was named Outstanding Citizen in 1983 for tireless work with Boy Scouts and other organizations and for donating, along with his wife, Lucille, their historic family home to the Smithville Heritage Society for use as a museum.

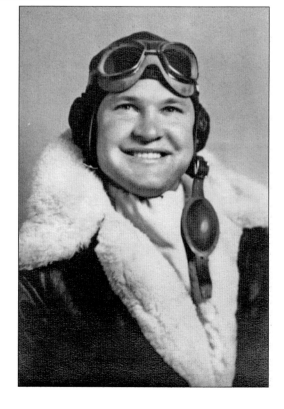

Happily pictured during World War II, Francis E. "Babe" Shirocky, Rice Institute graduate, was ultimately a rancher, a football coach, and a grocer. In the 1960s and 1970s, Babe garnered support from Texas politicians and influential Smithville civic leaders to make Science Park–Research Division a reality. He "saved" city hall's cupola from destruction when city hall was torn down in 1968, and it now tops the gazebo in Railroad Park.

A Texas "T patcher," 36th Infantry Division, during World War II, Beverly W. "Dube" Allen received a private audience with the Pope while stationed in Rome. After the war, a government helicopter made an emergency landing at his Humble station at Highway 71 (now Highway 95) and the Colorado River. Dube filled it with 26 gallons of gas and never received reimbursement. Dube, here with his wife, Lou, was postmaster of Smithville for many years.

Conductor Eddie H. Garrett is shown with a military policeman in the MK&T yard. During World War II, troop trains often stopped in Smithville for servicing and to pick up water for the steam boilers. Smithville patriots and well-wishers would go to the train and talk with the troops, who were usually on their way overseas. Occasionally, the troops had candy or chewing gum available to treat the small children.

Schoolgirls helped their mothers manage food rationing, learn efficient dietary planning, and work in victory gardens. When practical, they assisted in Red Cross activities and attended USO functions to entertain the locally based troops. Schoolboys took on their father's chores to the degree possible; and after school each day, they collected scrap iron and steel to provide material to build needed war machinery.

In the 1940s or 1950s, the First Methodist Church holds an after-church homecoming luncheon in front of the church, right in the middle of Olive Street just north of Fourth Street. One advantage of living in a small town is that events like this can occur, and none of the neighbors seem to mind it. Maybe their church will block the street for something next week.

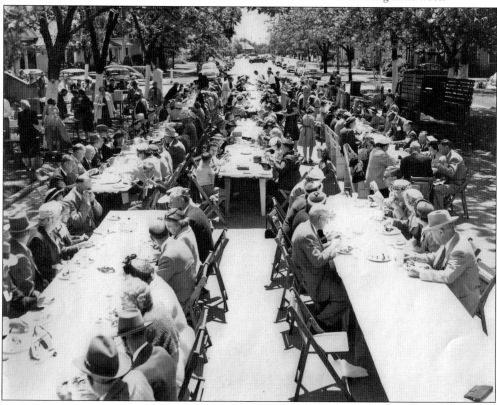

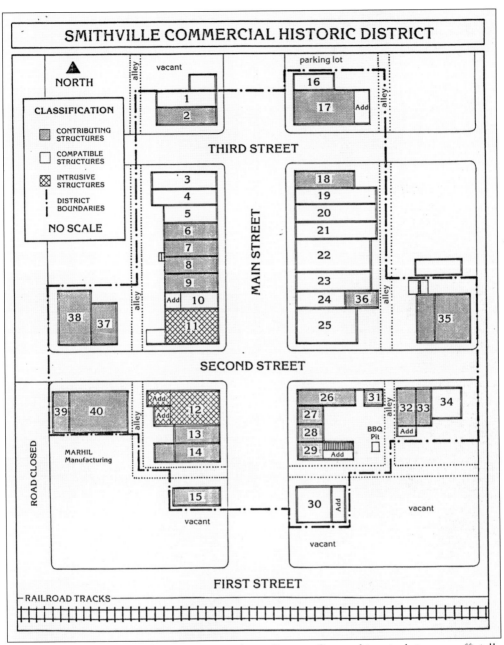

SMITHVILLE COMMERCIAL HISTORIC DISTRICT

NORTH

CLASSIFICATION

- CONTRIBUTING STRUCTURES
- COMPATIBLE STRUCTURES
- INTRUSIVE STRUCTURES
- DISTRICT BOUNDARIES

NO SCALE

vacant

parking lot

THIRD STREET

MAIN STREET

SECOND STREET

MARHIL Manufacturing

ROAD CLOSED

BBQ Pit

vacant

vacant

vacant

FIRST STREET

RAILROAD TRACKS

The Smithville Commercial District, a significant Bastrop County historical site, was officially listed in the National Register of Historic Places on June 17, 1982. Nominated by the Texas Historical Commission, the site was formally recognized for its contribution to the history of the American people. The Smithville Commercial District is a noteworthy example of c. 1900 business districts of small Texas railroad towns.

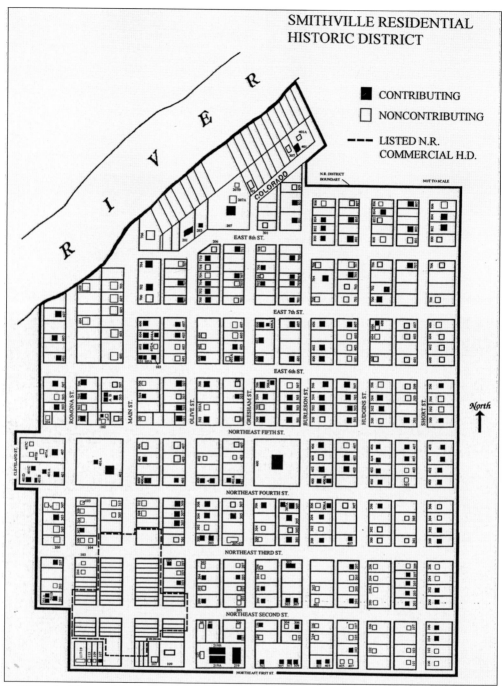

In 1996, the National Park Service notified Cherrell Rose and the Smithville Heritage Society that the Smithville Residential Historical District was entered in the National Register of Historic Places. The district includes nearly 50 blocks, with properties dating from 1887 to 1945. The Texas Historical Commission reported the largest number of contributing homes was represented by Queen Anne, classical revival styles, and bungalow and pyramidal-roof houses with Victorian elements.

Four

POSTWAR YEARS
AND TRANSITION

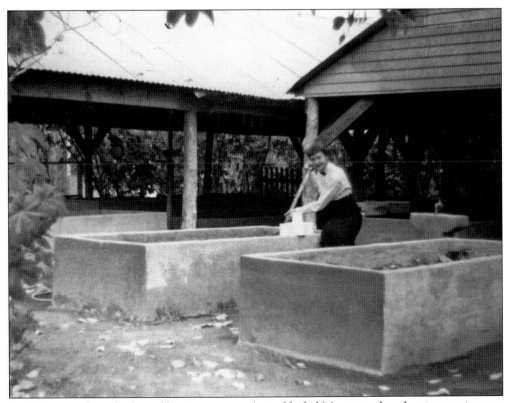

In 1950, versatile and talented businesswoman Anita Heckel Mize introduced an innovative new industry to Smithville when she established her earthworm hatchery just south of the Katy rail yard. Using custom-designed concrete reproduction and growth containers, located under overhead protective coverings, tens of thousands of wiggling, crawling creatures were soon reproducing at a rate profitable enough for commercial purposes.

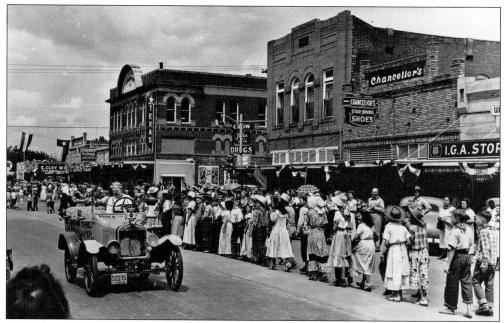

The Frontier Days celebration and parade resumed after World War II. Spectators and participants in vintage costumes give this rodeo clown's car a wide berth, as he prepares to rear it up on its back wheels and drive it with its front wheels airborne. The Kerrville bus terminal, Piggly Wiggly grocery, Rabb McCollum Building, Texas Theater, Crow Pharmacy, Chancellors Dry Goods, and the IGA grocery join other merchants in welcoming the homecoming attendees.

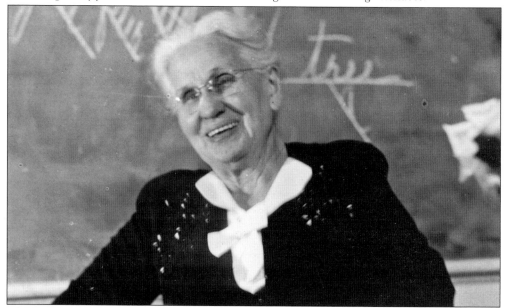

Three generations of Smithville's children had their lives favorably influenced and enhanced by Lillian G. Tippen, who taught here for over 40 years of her 52-year teaching career. She served as Central School's principal and English teacher. Having attended college at Baylor University, the University of Texas, and Southwest Texas State Teachers College, she had stellar credentials. She was born in 1876, retired in 1949, and died in 1970.

At least four generations of Smithville schoolchildren were fortunate to have Marie Caroline Niehbur teach them math during their Sam Houston Junior High days. A graduate of Blinn College with a master's degree from the University of Texas, Marie served as school principal for 35 years of her 50-year teaching career. She was a member of Delta Kappa Gamma sorority and a member of Smithville's First United Methodist Church.

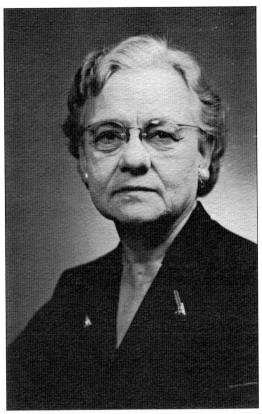

In the mid-1950s, Smithville football games and parades were not complete without uniformed marching bands preceded by escorts of beautiful young girls in striking attire, proudly demonstrating their twirling abilities. Today band uniforms are more comfortable and casual, twirlers have evolved into flag corps or dancing groups, and military marching styles have been replaced with creative and interesting field formations.

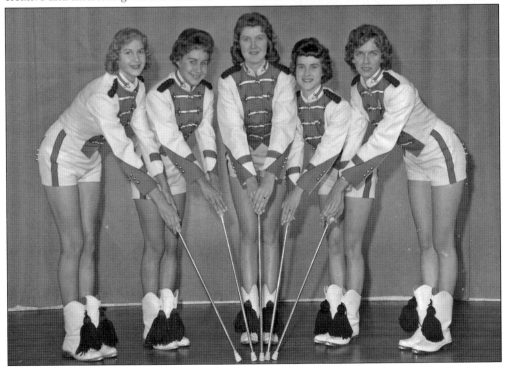

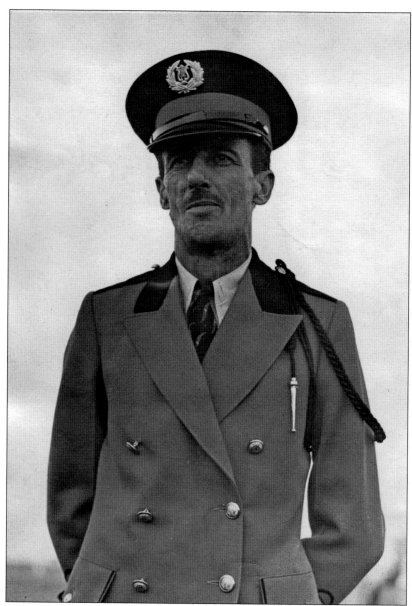

Burnett "Blondie" Pharr directed the U.S. Military Band and performed before Queen Elizabeth during World War I. At the University of Texas, he became Longhorn band director, assisted in writing "Texas Fight," and conducted the band through a nationwide concert series ending with President Roosevelt in the White House. In 1937, Burnett Pharr chose to further his teaching career here. Since Smithville lacked a school song, he used the "Our Director" music score and adapted the "Tigers Honor" lyrics to accompany it. Under his direction, the school band succeeded in winning ribbons in statewide and national music competitions. As tennis instructor, he coached girls who became statewide tennis champions. His high school principal's activities included dramatics, counseling, and teaching. In the early 1950s, Burnett retired from the teaching profession and returned to Austin, where he finished out his active career by serving the Austin Parks and Recreation Department as their professional tennis instructor. The Pharr Tennis Center in Austin is named in his honor.

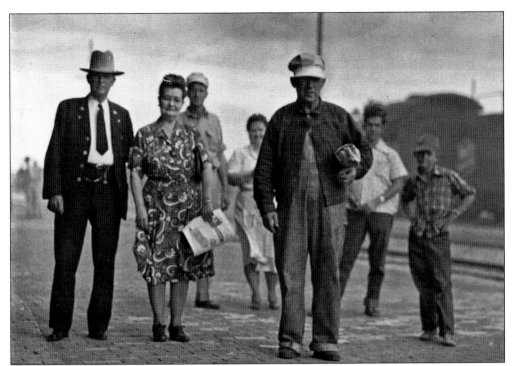

Retiring MK&T steam engineer Edward Elsworth Bollier walks away from his engine after completing his last career run on the Katy. He is joined on this memorable occasion by, from left to right, by his longtime friend and conductor Whit Turney; his wife, Dessie Mae Bollier; his son-in-law, Thomas Herrington; his daughter, Irene Herrington; and his grandsons, Tommy and David Herrington. Shortly afterward, diesel engines replaced the steam engines in Katy service.

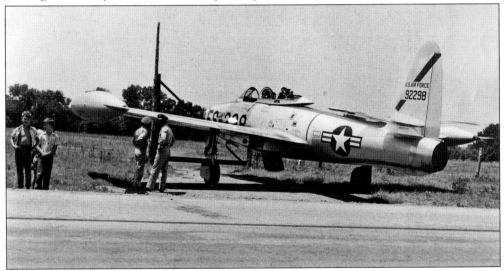

In 1950, the old Powell stagecoach station had an unexpected visit by Capt. Glen Dunaway, who made an emergency landing in America's newest fighter aircraft, the F-84F. He landed safely on the Austin highway after local ranchers blocked automobile traffic for him. Strict security shrouded the event and the entire area. (Luckily, the subject photograph was not confiscated.) After repairs, the plane flew to Austin's Bergstrom Air Force Base.

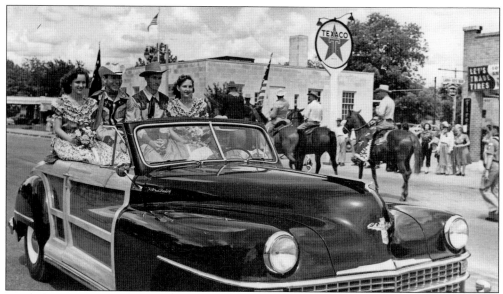

Around 1950, the annual Frontier Days parade was still going strong. Cowboys and their ladies ride in this classic 1946–1948 Chrysler Town and Country convertible coupe at the corner of Main and Fourth Streets, with the post office and part of the Texaco behind them. In these days, the parade went south on one side of the street, did a U-turn, and then went north on the other.

Every American town needs a queen, and Smithville is no exception. Part of the Jamboree tradition is a very well attended Jamboree Queen Coronation evening. The judging is patterned after the Miss America pageant, and in addition to modeling in evening wear and being interviewed, the contestants must demonstrate a talent. The Smithville Jamboree Queen participates in other towns' parades and celebrations, a reciprocal custom.

Maximilian "Max" Carl Marburger was born in 1879 in Cistern near the Anchor Ranch he later owned. He married Clara Mensing in 1903, and they had four children. Widely known in Bastrop and Fayette Counties in World War II as Victory War Bond chairman for Cistern, Max raised far more than their $18,000 quota. He served on the Smithville school board for 10 years. He died in 1975 and is buried in Oak Hill Cemetery.

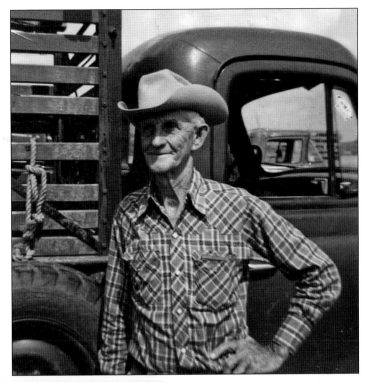

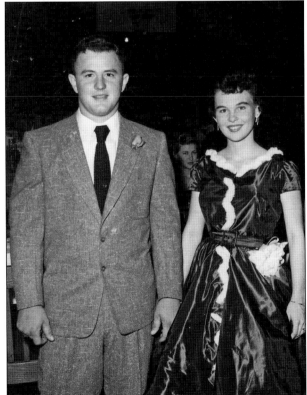

Jerry Fleming, 1954 recipient of the Bobby Schott Memorial Athletic Award, and his wife and football sweetheart, Evelyn, display the pleasure of association they have with sports. A Smithville Tiger team captain, member of All-District and All-Central Texas football teams, and student body president, Jerry exhibited those outstanding qualifications that Bobby Schott had lived, inspired, and aspired to achieve during his short lifetime.

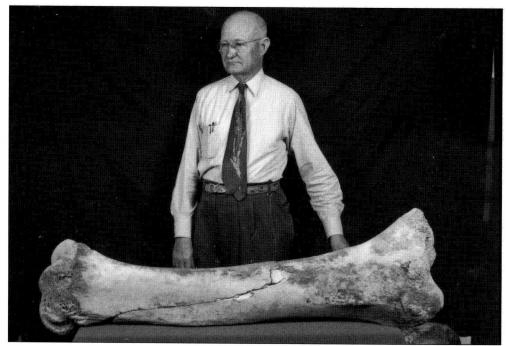

Johnny Stalmach, prominent Smithville businessman, found this prehistoric mastodon bone, which dated back 40,000–50,000 years ago, and gave it to Smithville High School. Located in a gravel gulley between two small hills, the 80-pound bone was 4 feet, 2 inches long and 14 inches in diameter. Dr. John Wilson, UT geologist, described it as the upper leg bone of a young cousin of today's elephant, according to the March 10, 1955, *Houston Post*.

The Cactus Cafe, once an institution in Smithville, opened about 1930 at the corner of First and Main Streets. Originally called "Boxcar" because of its shape, it eventually moved into the old Texaco station next door. Sandwiches and drinks were served from here to Katy Railroad passengers, as well as troop trains during World War II. Legend has it that notorious outlaws Bonnie and Clyde once ate at the Cactus.

Located on present Highway 95, where the Brookshire Brothers grocery store is currently located, are Harris Electric Manufacturing Company and the Southland Ice Company during the 1950s. Southland Corporation, at the time the fifth largest ice company in America, bought the local ice company in 1948. The top of the "Tin Man" water tower is in the foreground.

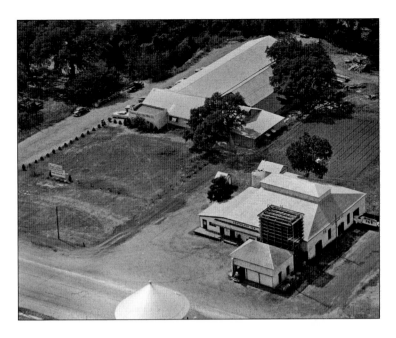

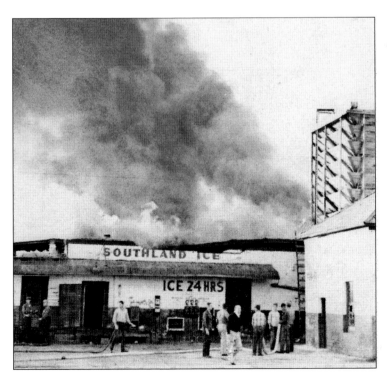

An era of home delivery ice and commercial ice block refrigeration ended abruptly on Tuesday, January 16, 1962, when a most unexpected event happened. The Southland Corporation's ice manufacturing plant caught fire and burned beyond repair. Damage was estimated at $50,000, and the cause was undetermined. Historically, the plant had furnished bulk block ice to the railroad to refrigerate their perishable railcar shipments.

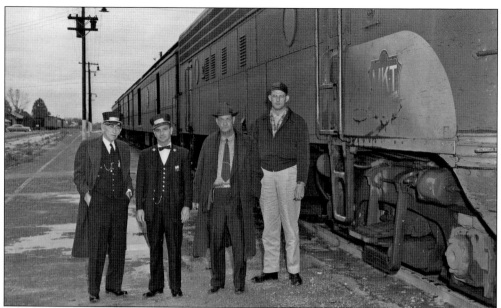

On November 11, 1957, Adena Lewis, current president of the Smithville Chamber of Commerce, as a fourth-generation railroad child, took rides with her grandmother, Maggie Guyton, on the last two passenger trains out of Smithville, Texas, just before passenger service was eliminated. The morning northbound passenger train, No. 22 (above), en route to Waco, included, from left to right, crewmen Tom Bullock, Henry Zimmerhanzel, Lonnie Yancey, and H. M. Willets. The afternoon eastbound passenger train (below), en route to Houston, included, from left to right, crewmen Harry Tidwell, Haney DeLoach, and Fred Moree. All along both routes, the trains carried their biggest passenger loads in many years as proud railroaders took their children and grandchildren for their last Katy train ride. On that solemn date, 20 longtime MK&T families lost their jobs. In 1950, when two night passenger trains were eliminated, a similar loss of employment and family impact occurred.

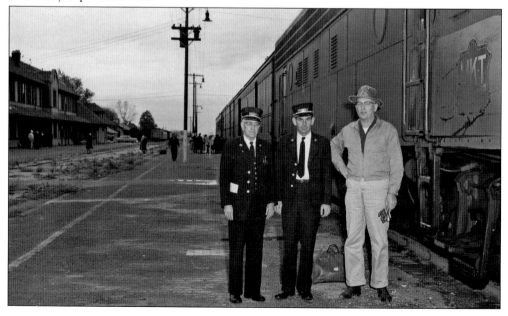

Outstanding high school student Donald John Matocha earned a bachelor of science in engineering in three and a half years at Texas A&M University. In 1968, Donald was killed in Vietnam, but his body was not found at the time. His sisters and POW/MIA representatives spent years trying to locate his body. Finally, on September 23, 2004, Second Lieutenant Matocha came home to rest in Smithville. (Courtesy the family of Donald Matocha.)

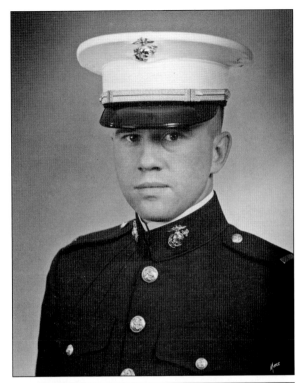

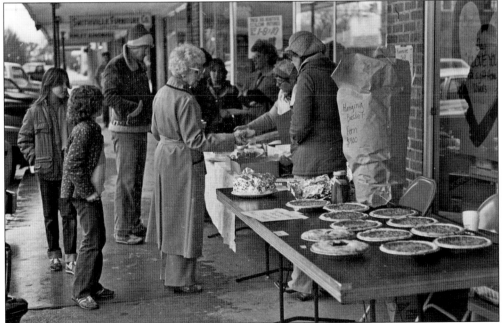

Things may change fast in some cities, but not so much here. Bake sales like this one in the late 1970s are still held today on Smithville's Main Street. Auctions, raffles, and fried chicken or catfish dinners are all reliable fund-raisers for the Volunteer Fire Department, Friends of the Library, civic organizations, and churches. Personalized benefits are often held to help those stricken by serious health problems or other tragedies.

Dick Burdick founded the Central Texas Museum of Automotive History as a nonprofit educational foundation in 1980. Located near Rosanky, about 10 miles west of Smithville, the museum is dedicated to collection, restoration, and preservation of historic automobiles and their accessories. The collection is housed in a 40,000-square-foot, climate-controlled building and traces the evolution of the automobile from the dawn of the 20th century through modern times.

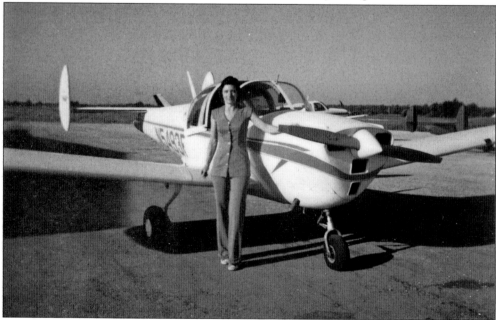

Private pilot and retired Bastrop County judge Peggy Walicek is shown with her first airplane, a 1946 Aerocoupe, at Smithville's jet-capable Crawford Municipal Airport, Federal Aviation Administration Identifier 84R. Bastrop County's only airport offers flight instruction, fuel, maintenance, a rest stop with a superb pilot's lounge complete with Internet connection, overnight tie-downs, and resident hangars. Ultralights and skydivers have also been seen enjoying Smithville's airport.

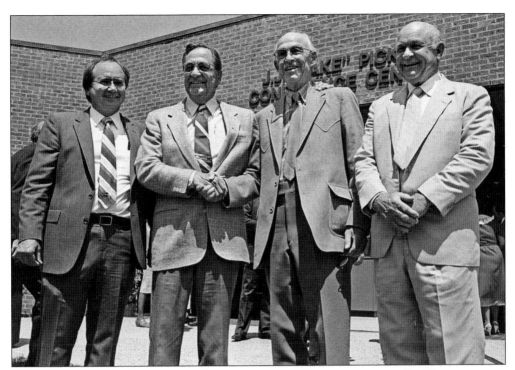

Located near Smithville since 1977, the University of Texas M. D. Anderson Cancer Center, Science Park–Research Division is a recognized world leader in carcinogenesis research and cancer prevention. Celebrating the dedication of J. J. "Jake" Pickle Conference Center are, from left to right, Science Park–Research Division director Thomas J. Slaga, U.S. Congressman Pickle, M. D. Anderson Cancer Center director R. Lee Clark, and Smithville businessman Francis J. "Babe" Shirocky. (Courtesy Science Park–Research Division Library.)

This plaque acknowledges several Smithville citizens who contributed to Science Park–Research Division: the Emil Buescher family, for donation of state park land; city councilmen Martin Goebel, E. E. Hollub, Weldon D. Mays, J. D. McBee, and A. J. Novosad; Mayors George S. Woodress, Albert E. Crawford, and Lawrence Skelley; and Francis J. "Babe" Shirocky and Bastrop County citizens. (Courtesy Science Park–Research Division Library.)

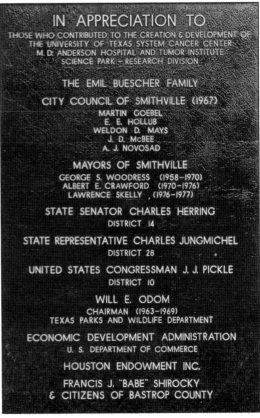

IN APPRECIATION TO
THOSE WHO CONTRIBUTED TO THE CREATION & DEVELOPMENT OF THE UNIVERSITY OF TEXAS SYSTEM CANCER CENTER M. D. ANDERSON HOSPITAL AND TUMOR INSTITUTE SCIENCE PARK – RESEARCH DIVISION

THE EMIL BUESCHER FAMILY

CITY COUNCIL OF SMITHVILLE (1967)
MARTIN GOEBEL
E. E. HOLLUB
WELDON D. MAYS
J. D. McBEE
A. J. NOVOSAD

MAYORS OF SMITHVILLE
GEORGE S. WOODRESS (1958–1970)
ALBERT E. CRAWFORD (1970–1976)
LAWRENCE SKELLY , (1976–1977)

STATE SENATOR CHARLES HERRING
DISTRICT 14

STATE REPRESENTATIVE CHARLES JUNGMICHEL
DISTRICT 28

UNITED STATES CONGRESSMAN J. J. PICKLE
DISTRICT 10

WILL E. ODOM
CHAIRMAN (1963–1969)
TEXAS PARKS AND WILDLIFE DEPARTMENT

ECONOMIC DEVELOPMENT ADMINISTRATION
U. S. DEPARTMENT OF COMMERCE

HOUSTON ENDOWMENT INC.

FRANCIS J. "BABE" SHIROCKY
& CITIZENS OF BASTROP COUNTY

In a pine forest a few miles from Smithville, the quest for a cure for cancer and related diseases forges on at University of Texas M. D. Anderson Science Park–Research Division. Resident faculty discipline expertise includes cellular and molecular biology, biochemistry, immunology, pharmacology, virology, and genetics. This campus offers opportunities for research training at undergraduate, graduate, and postdoctoral levels. Here lecturing is Dr. Ronald Humphrey, associate director of Science Park–Research Division 1977–1980.

Dr. Ellen Richie performs tests in a Science Park–Research Division lab during the 1980s. Although research here focuses on cancer, particularly its origins and possible prevention, it can lead to discoveries in other fields of medical research. The quality of the research programs is seen in the high level of productivity, success in receiving grant support, and recognition received both nationally and internationally.

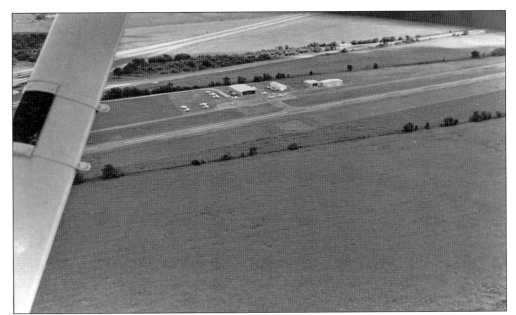

The picture above was taken in 1986 from a plane flying over the Smithville Crawford Municipal Airport, owned by the City of Smithville. The jet-capable airport primarily serves the recreational market, with 35 planes and three ultralights based on the field. The airport was dedicated in 1976 and again in 2001 after a runway expansion project.

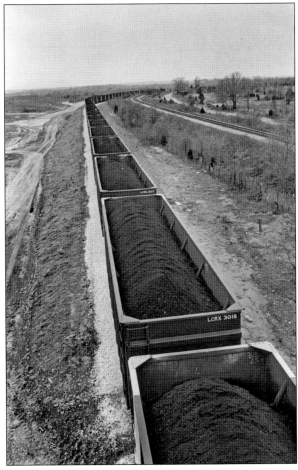

Pictured here in 1986 are a few of the 2,000 coal cars currently owned by the Lower Colorado River Authority (LCRA). This is one train out of the many that have in the past hauled coal through Smithville to the nearby Fayette Power Project power plant. The Fayette Power Project, operated by the LCRA, burns the equivalent of one and a half trains per day, over 200 carloads, in order to produce electricity for central Texas.

In 1987, Mayor Bill Davidson declared "Margaret Webster Day" to honor her many contributions to Smithville. As a VFW Ladies Auxiliary member, Webster wrote plays for VFW fund-raisers. As owner of Community Business Service, she received awards from Smithville Business and Professional Women's Club. Margaret was secretary of Smithville's first Railroad Park Board. She was a prolific donor to Smithville Heritage Society, providing many local histories of people and organizations.

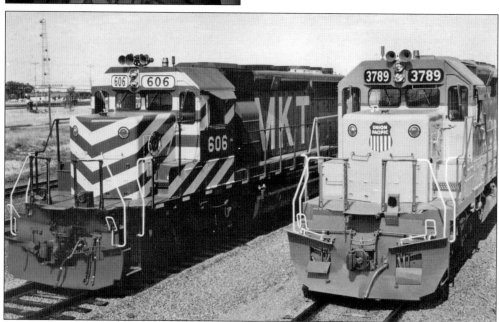

Union Pacific engine No. 3789 is ready to "throttle-up" and move forward, while Missouri, Kansas, and Texas engine No. 606 prepares to "pull-the-air" for the last time and fade into history. On August 12, 1989, the MK&T, was bought by the Union Pacific Railroad. Just as the Taylor, Bastrop, and Houston Railway Company had evolved into the MK&T many years before, another era of railroading ended for Smithville, Texas.

Tireless volunteer James Long accepts a tree for the park that was named for him. Pictured with him are, from left to right, (first row) Mayor Vernon Richards, Beverly Saunders, Wilma Rice, and Jeanette Walker; (second row) Eleanor Mutschink, Metta Johnson, and Joyce Klutts. The small depot they are standing near was found in nearby West Point, moved to the James Long Railroad Park, and lovingly restored. Long was recognized as the Smithville Citizen of the Year in 1988.

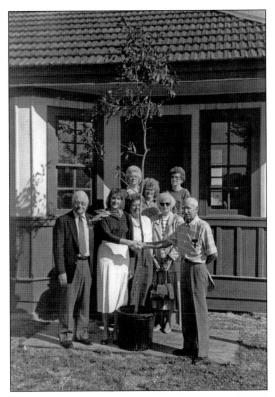

The Smithville Police Department, a valuable interactive community resource, is headquartered in this structure located at the corner of West Fourth and Ramona Streets. This building, which also houses the police holding facility, has a history of being utilized by the Department of Public Welfare, the Precinct Justice of the Peace, the Texas Department of Public Safety, the Bastrop County Tax Office, the Precinct Constable, and the Volunteer Fire Department.

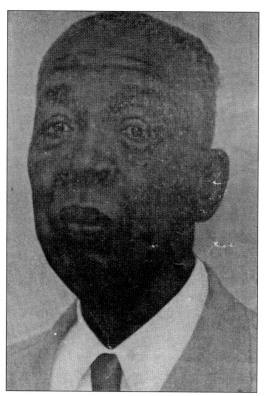

Pendergrass Funeral Home was organized by Thomas Pendergrass Sr. (left) in 1921 and located on West First Street in a building he purchased in 1916. Pendergrass, born near Smithville in 1875, operated various businesses including a grocery store, café, barbershop, wood yard, and the funeral home and burial association before dying in 1962. Meanwhile, his son Thomas Jr. (below), who graduated from Warsham School of Mortuary Science in Chicago, returned to Smithville in 1956. With his wife, Iva Smith Deary, he bought the Peoples Funeral Home at 305 West Third Street. In 1960, Thomas and Iva took over the Pendergrass business from his father and merged the two into the present Pendergrass-Peoples Mortuary. Both father and son were held in the highest regard for their long and illustrious career of service to the community. The Pendergrass motto was "Honesty is the Best Policy; Truth and Right Will Prevail."

Ninety-seven-year-old Joel A. "Old" Joe Cole—cattleman, horse trader, rawhide furniture maker, and writer of Western articles—was laid to rest at his country homestead in 1999. Joe never forgot his roots, and he surrounded himself with treasures from the past so that important memories would not be lost. He also shared these memories in the stories he wrote for *True West Magazine*.

The good old days reflect in this photograph of "Old" Joe Cole's original log cabin home and tool shed, which includes hand-crafted farming and ranching implements. The hand-hewn shape of each log in the cabin is individually exact, to properly mesh together at each juncture. Note the creativity in carving the three-pronged pitchfork for handling hay and the custom handles and heads for the rakes.

William "Willy" Mikulec (left) and Raymond Mikulenka (right) hold the large catfish they caught in the Colorado River while fishing with rod and reel equipment. Buescher and Bastrop State Parks have nice angling lakes as well as camping facilities, and the LCRA power plant recreational lakes near Bastrop and La Grange also offer excellent fishing. Smithville's Riverbend Park offers a fishing pier and overnight camping adjacent to the Colorado River.

Smithville prides itself on being a clean city, and it has numerous awards to prove its past successes; even the governor of Texas has presented certificates to the mayor in acknowledgment of and appreciation for the city's efforts to earn and maintain that status. Each year, scheduled clean-up days send volunteer crews with trucks and trailers across the city, providing citizens an outlet for their unwanted items.

Robert Saunders (left), retired state representative from the Smithville district, visits with longtime Fayette County sheriff Jim Flournoy (right) in front of the historic Fayette County Courthouse in La Grange. This magnificent structure was recently restored to its original grandeur with a central atrium that rises the full height of the building. The District Courtroom was used during the 2008 filming of the movie *Tree Of Life*, starring Brad Pitt and Sean Penn.

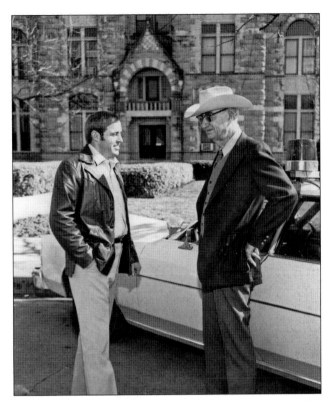

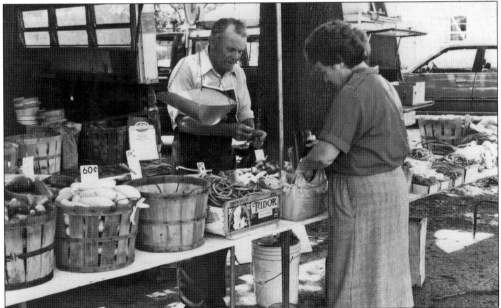

Almost every town and city in the United States, including Smithville, has a market where farmers bring seasonal crops to sell directly to customers. Each Thursday, local farmers bring vegetables, fruits, and homemade baked goods to Smithville's Farmers Market. When this picture was taken, the market was held in the parking lot of St. Paul the Apostle Church, but in 2007, it moved to the gazebo at the end of Main Street.

The Smithville Heritage Society honored several of the local women who served their country during World War II with a public memorial exhibit proudly displayed in the society's location on Main Street. The honored guests include, from left to right, Connie Beekley, Dorothy Thomas, Nell Haisler, and Leah Edwards.

Willy Hall (right) was well known around town as a polite and well-dressed gentleman. He was often seen walking from his residence at Smithville's Towers Nursing Home to his church on Sunday and always had time to stop and exchange pleasantries or to wave to drivers passing by. At his home away from home, he assisted the other residents, and he was honored here on the occasion of his birthday.

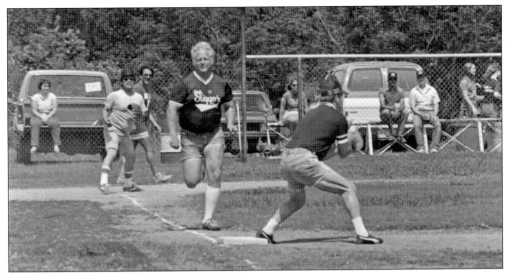

Everyone who met C. T. (Carmen Terrell) Saunders quickly learned that he loved baseball, especially the St. Louis Cardinals. An SHS Tiger baseball player, C. T. chose his career with the Texas Highway Department in Austin. His career ended suddenly with his death in a tragic automobile accident, but his coworkers honored his memory with annual baseball tournaments held here in his hometown. Younger brother Gary is shown approaching home plate.

Clarence C. Karcher (right), veteran SHS vocational agriculture teacher, receives his Forty-Year Service Award from Jose Correa Jr., of Mission, Texas, who made the presentation on behalf of the Vocational Agriculture Teachers Association of Texas. A graduate of Texas A&M University, Karcher was an inspiring instructor and role model who was respected and admired by his numerous students.

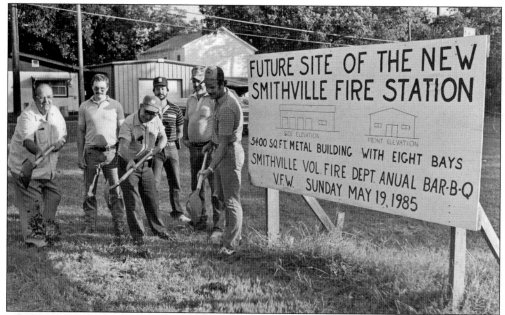

FUTURE SITE OF THE NEW
SMITHVILLE FIRE STATION

SIDE ELEVATION FRONT ELEVATION

5400 SQ.FT. METAL BUILDING WITH EIGHT BAYS
SMITHVILLE VOL. FIRE DEPT. ANUAL BAR-B-Q
V.F.W. SUNDAY MAY 19, 1985

After many years in the station behind city hall, in 1985–1986, the Volunteer Fire Department built a new fire station at Loop 230 and Cleveland Street. The city provides partial funding for the fire department, but it relies a great deal on the annual dinner and auction to raise money for new firefighting suits and equipment. A very popular fund-raising and social occasion in Smithville, this event always attracts an overflow crowd.

With poinsettias and a Christmas tree decorating the serving area, from left to right, Virginia Fulmer, Delores Burns, and Lawrence Wesson partake of the festive seasonal treats at a community-wide open house. Such events are still held, often sponsored by local businesses as a small token of their appreciation for customers' loyal patronage. The holiday spirit is further exemplified by the annual downtown lighting project and the beautiful Festival of Lights nighttime parade.

Alma Steinbach Pencik Vasek shows excitement at winning the bingo game. The Veterans of Foreign Wars and the American Legion afford players the opportunity to relax, socialize with friends, and enjoy themselves while helping fund the community service projects of the hosting organization.

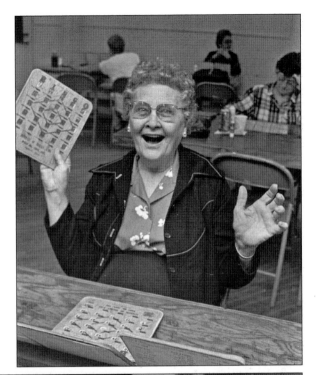

This young Cub Scout's Pinewood Derby car obviously won. Sponsored by the First Methodist Church, Smithville's Boy Scout Troop and Cub Scout Pack have had active programs in Smithville for over 60 years, with a commendable number of young men achieving Boy Scouts' highest rank, that of Eagle Scout. Smithville's Girl Scout programs have also been active for many years, and they are known for their famous January Girl Scout Cookie sales.

A friendly visit and helping hand brighten the day for this resident as she enjoys the outdoor patio of Towers Nursing Home. Her shade is provided by the old oak tree that stood at the Adamcik family home near Short and Colorado Streets. The historic Thorn house can be seen in the right background. Old Smithville was situated in this area before it moved to meet the railroad.

Bonnie Parker felt as comfortable at male-dominated auction barns and livestock sales as she did on her own 100-year-old cattle ranch near historic Gotier Trace, which was once traversed by early pioneers and settlers. The ranch included a handcrafted log cabin with a sign proclaiming it "Puss Hollow" Ranch. According to topology maps, it was located just down the trail from "Pigeon Roost Hollow."

Felix Chrastecky, star Tiger football quarterback and longtime package store owner, also liked to breed and sell game roosters behind his place of business on Highway 95 South. Smithville businessman Babe Shirocky dubbed Felix "T-Pot" because as a young boy he would always dance and sing, "I'm a little teapot, short and stout. Here is my handle, here is my spout." Sports announcers preferred "T-Pot" because they could not pronounce Chrastecky.

Although greatly reduced from Smithville's railroad heyday by the 1970s and 1980s, the Missouri, Kansas, and Texas workforce still accounts for a significant number of the town's residents. Employees are required to hold regular safety meetings, with attendance reported as part of their personnel records.

Young Sabrina Griffin and Shametra "Peaches" Griffin, dressed in their Sunday best, enjoy the bright, sunny morning in 1987 as they leave church services at Mount Pilgrim Baptist Church on Walker Street. Rev. L. K. Williams became minister at Mount Pilgrim in 1982 and remained there for many years.

The Smithville Food Pantry, located at Second and Lee Streets, is a voluntary, community-based project that provides supplemental food to families and individuals who are temporarily in unfortunate situations of need. Begun as a Methodist church ministry, the activity has evolved with support from the city, county, LCRA, Roving Volunteers in Christ's Services (RVICS), churches, service organizations, businesses, and caring individuals. To the extent possible, special dietary needs are addressed. (Courtesy David L. Herrington.)

Five

INTO THE 21ST CENTURY

Pilots and passengers departing their aircraft at the Smithville Municipal Airport, 84R, are welcomed by the airport's modern Pilot Lounge, established in memory of Irvin A. Row, lifelong aviator, 50-year flight instructor, retired career military pilot, and flying club member, as well as retired high school teacher, band director, and hospital administrator. Airport visitors are welcomed by this sign at the highway entrance. (Courtesy David L. Herrington.)

During a Smithville Fly-In at Smithville Crawford Municipal Airport, 84R, a colorful hot air balloon is ready to rise above airport hangars and the pilot's lounge, just out of sight to the left. The "Tin Man," an old Smithville water tower still in use today, stands proudly over the town and the airport. A feather-light airplane lands on the runway to the right. (Courtesy Bob Parker.)

Orbiting Shuttle and International Space Station astronauts can easily read the name "LUECKE" situated just north of town. The individual letters have been sculpted out of the native forest on the Luecke family farm. This modern landmark is also located just south of the historic Gotier Trace, a pioneering overland route taken by early settlers coming to Texas. (Courtesy Justin Kasulka, fimpress.blogspot.com/2006/09/luecke.)

Mayor Dr. W. R. Curham adorned the 1917 city letterhead with "City of Push, Plenty, and Prosperity" as the official motto. After World War II, technology and economic factors changed Smithville's employment base and source of prosperity. In 1961, businessman Francis "Babe" Shirocky and chamber of commerce president Weldon Mays changed the motto to "The Heart of the Megapolis." Welcome signs exhibiting the motto greeted visitors. Megapolis, defined as an extensive metropolitan area, is appropriate for Smithville's central location in the large triangle formed by connecting Austin, San Antonio, and Houston. Today's city prosperity is rooted in a quality of life enhanced by an accredited school system, trauma-care-rated regional hospital, recreational parks, historical museums, modern municipal airport, acclaimed volunteer fire department, responsible city government, and scheduled recreational and promotional events. A new sign welcomes visitors with the modernized spelling of "Megalopolis." (Below courtesy David L. Herrington.)

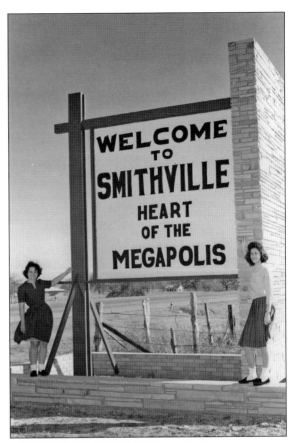

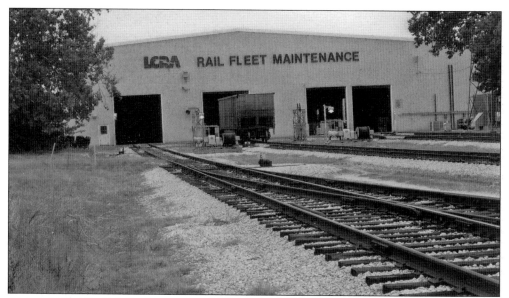

Although Smithville's heyday as district headquarters and maintenance shops for the MK&T Railroad are long gone, the Lower Colorado River Authority's Rail Fleet Maintenance Facility maintains some 2,000 railcars that bring coal from Wyoming to the Fayette Power Project power plant. The work performed at the facility includes all types of railcar maintenance and also steel fabrication work for a variety of projects within the LCRA. (Courtesy David L. Herrington.)

Dr. Ravi Parchuri, beloved physician in the community, was posthumously honored on June 29, 2008, for his many years of dedicated service and numerous contributions to Smithville, his patients, and the regional hospital. Before a crowd of family, friends, patients, and admirers, the Smithville Regional Hospital Auxiliary dedicated a beautiful memorial meditation garden, which they and respected community benefactors had constructed in his memory.

Springtime affords young Smithville beauties Stephanie McMillan (left) and Elizabeth Duncan (right) the opportunity to commune with nature and flirt with their companion as they enjoy the outdoors. Not much has changed since this hobby was prevalent in the 1920s except the type of camera. Modern young people use a digital camera or their cell phones instead of a Kodak Brownie.

Smiling volunteers Eric Meyer and Brenda Mancini beam in the sunlight as they busily enhance the appearance of the Railroad Park's grounds and flower gardens. The stoic Tiger football team mascot is stationed nearby to greet visitors to the chamber of commerce, visitor center, and museum. In the background, three-wheeled bicycles await energetic tourists to take them for a spin around the downtown historic district. (Courtesy David L. Herrington.)

From left to right, Klauspeter Hopp, Walter Pfiester, and Tommy Hancock relax while enjoying the fellowship and conversation at Huebel's. This establishment began just after World War II as a garage where war veterans were trained in auto mechanics under the GI Bill. As the years went by, it evolved into a garage with a few groceries, then into a garage-grocery with a few tables for beer-drinking domino players, and then into today's family social gathering retreat. (Courtesy David L. Herrington.)

Billy Davis (second from right), mentor and retired Bastrop County commissioner, is joined by regulars on his service station bench to discuss recent local events and prognosticate about Smithville's future. Mike Bratcher (far left), retired railroader, rests his sore leg while Charlie Williams (second from left), retired coach and railroader, quotes words of wisdom as Brother Bubba Fowler (far right) looks on with interest. Only Billy is aware of the photographer's intrusion into their tranquil space. (Courtesy David L. Herrington.)

Another Smithville quality of life innovation is developing. The concept of an unaffiliated not-for-profit clinic to provide minor medical treatment to uninsured financially challenged members of the community is progressing beyond its embryonic stage. Individual citizens, private and religious benefactors, retired medical professionals, and other skilled volunteers are coming together to make this concept a reality. Land has been acquired, interim grants submitted, and facility development is underway. (Courtesy David L. Herrington.)

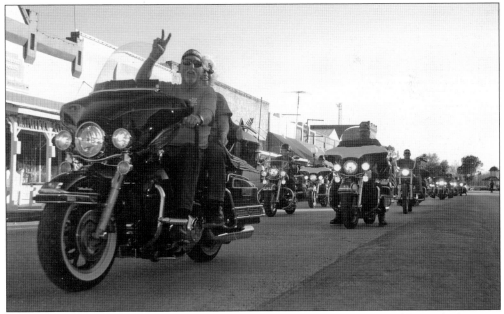

Thunder on the Colorado, Smithville's annual three-day biker rally, is held beneath the giant oak trees of Riverbend Park just off Highway 71 at the Colorado River. This motorcycle gathering features entertainment including live music, dancing, a bike show, artisan vendors, biker games, fun rides, a fun (poker) run, an impressive street parade, and camaraderie in general. Santa Claus has even made an early appearance. (Courtesy *Smithville Times*.)

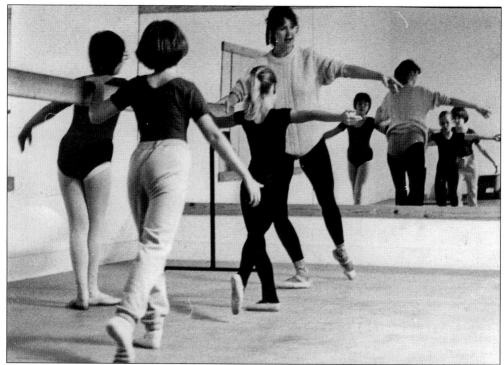

For some Smithville children, the first education they received from outside the family and church came through the efforts of Holly Fritz, owner of Smooth Moves dance studio. Poise, pride, self-confidence, team effort, obedience to instruction, and commitment to goals were the lasting benefits of the experience. Long after recital routines have been forgotten, other more valuable assets remain for a lifetime.

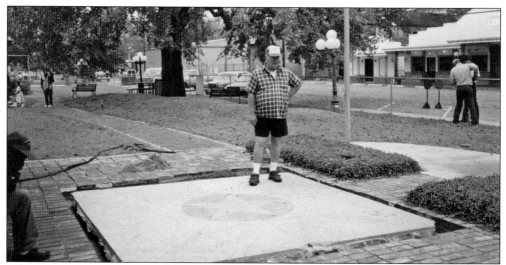

Artist and monument-maker Richard Ernest Heckel fabricated this star, a replica of the stone star at the state capitol in Austin, on his own front porch. When a fire destroyed the home in the 1990s, owner Clyde Schubert wanted to do something special with it. Working with Jack Page, the City of Smithville, and the LCRA, Schubert had the star installed in front of the Railroad Park Museum and chamber of commerce/visitor center.

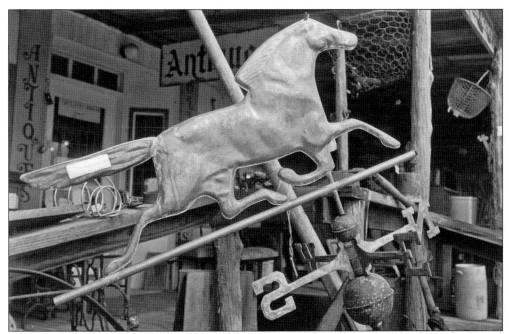

As this horse art suggests, movement is afoot in Smithville, particularly on weekends when artisans, tourists, and shopkeepers abound in this antique shopping mecca. Due to his love for the old lifestyle and its treasured memories, "Old" Joe Cole was credited locally with bringing antiques into vogue. Similar-minded tourists revel in the atmosphere and variety of artifacts and relics found within the local shops and stores.

Thomas Carter, a three-time Emmy Award winner, started as an actor but quickly moved into directing, both for movies and television. He has received the prestigious Directors Guild of America and the George Foster Peabody Awards. Born in Austin but raised in Smithville, Carter comes from a long line of educators and graduated from Southwest Texas State University. Carter directed the movie *Coach Carter* (not related), whose title character was played by Samuel L. Jackson.

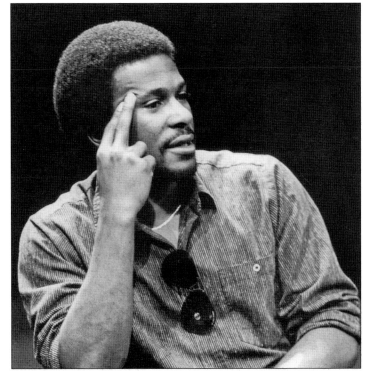

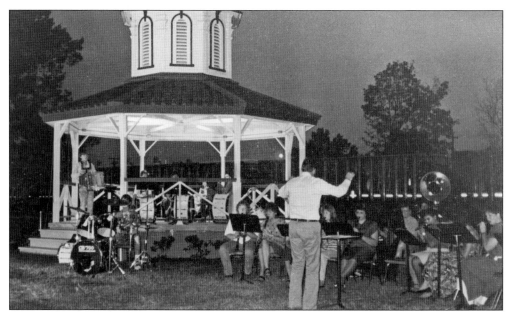

James Long Railroad Park houses the Smithville Railroad Museum, the Smithville Area Chamber of Commerce, a children's playground, public restrooms, and the gazebo. Musical programs, such as this school band playing in 1990, and other types of entertainment enjoy the charming wooden gazebo, topped by a cupola that was "rescued" by Frances J. "Babe" Shirocky when the old city hall building was torn down in 1968.

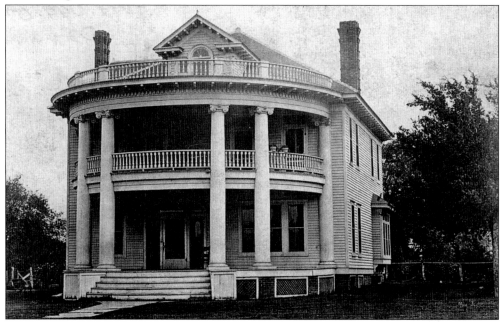

Used in the 1997 movie *Hope Floats* as Birdee Pruitt's childhood home, this neoclassical-style house on Eighth Street at the end of Olive Street was built for J. H. McCollum in 1908. McCollum was the local undertaker and buggy and carriage maker, and he had a large store on Main Street. In 1917, Dr. Phillip Chapman and his wife, Mamie Trousdale Chapman, purchased the house. It now belongs to her grandnephew.

The Chamber of Commerce 1996 Outstanding Citizen, Judge Clarence E. Culberson, was born and schooled in Craft's Prairie, married Tommye Dell Henderson, joined the air force in 1951, and after retirement, performed 10 years of civil service as fire inspector and assistant chief at Bergstrom Air Force Base. His Smithville activities include municipal judge, Smithville Honor Guard, MLK Organization, Noon Lion's Club, chamber of commerce, and Mount Pilgrim Baptist Church.

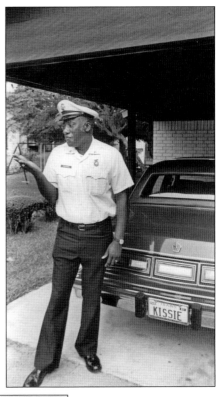

Smithville native LaVerne Harrell Clark, who died in February 2008, was a recognized author, photographer, and seventh-generation Texan. Her book *Keepers of the Earth* earned the Best First Novel Award from Western Writers of America. She met her husband, L. D. Clark, at Columbia University, where he received his Ph.D. L. D. He taught English for many years at the University of Arizona and has retired to Smithville, writing novels, novellas, and short stories.

A success story indeed, Pat and Sam Wolfensen started their tiny company in California in the 1960s and moved to Texas in 1975. Shown modeling a leather jacket with her husband, Sam, in leather vest, Pat started making handmade, carefully crafted couture Western wear under the label "Patricia Wolf," bridging Western styles with a contemporary look, which has become highly desirable in sophisticated worldwide markets. Patricia Wolf was named Texas Fashion Designer of the Year in 1988. (Courtesy Pat and Sam Wolfensen.)

Noted Texas jazz musician and composer Hannibal Lokumbe, or Hannibal as he is professionally known, was born Marvin Petersen in Smithville in 1948. His composition "African Portraits" has been played at Carnegie Hall and by the Houston Symphony Orchestra. Hannibal's great-grandfather and great-grandmother, a Cherokee shaman, are buried in Smithville's Clearview Cemetery. Since retiring in Bastrop County, Hannibal has directed musicians from local high schools in performing his compositions. (Courtesy *Smithville Times*.)

In 2004, Spiradrill, Inc., decided to relocate its construction and drilling equipment manufacturing facility to Smithville, Texas, having been based in California for 20 years. Jerry Wilkinson, owner and chief executive officer, wisely chose to locate the modern assembly plant for his highly respected truck- and track-mounted drill units adjacent to Smithville's Municipal Airport 84R, at the junction of State Highways 71, 95, and 153. (Courtesy Spiradrill, Inc.)

Every month's First Saturday event in Smithville brings out the artistic best of many of the area's talented artisans and creative crafters as they assemble around the gazebo in Railroad Park at the end of Main Street to display and market their respective products. Live musical entertainment emanates from the stage under the old city hall cupola while townsfolk, tourists, and shoppers alike all enjoy the carnival atmosphere. (Courtesy David L. Herrington.)

At the 2006 Festival of Lights, Smithville's chamber of commerce baked the world's largest gingerbread man. Volunteers worked for months planning the recipe, the baking form, and even the outdoor oven. He measured 20 feet tall, 10 feet wide, and weighed 1,308.5 pounds. Previous Guinness World Records winner was Universal Studios in Florida. The certificate from Guinness now hangs proudly in Smithville's city hall. (Courtesy *Smithville Times*.)

Tree of Life, directed by Terrence Malick and starring Brad Pitt and Sean Penn, was filmed in Smithville during spring 2008. Production manager Jack Fisk found "the" tree out at Les Hurta's place and moved it to a house in town for the tree scenes. For a while, Smithville was filled with producers, set and costume designers, and, of course, paparazzi. (Courtesy *Smithville Times*.)

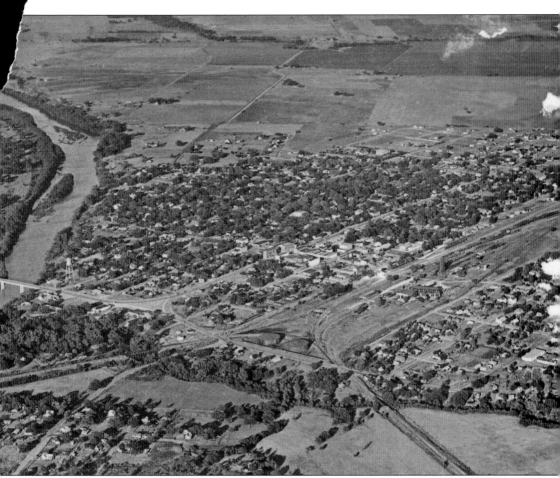

Leaving the Smithville area, readers can see the lower left quadrant of this northeasterly view very clearly showing the long string of trees lining Gazley Creek, where pioneer settler Thomas Jefferson Gazley chose his head-right land grant. The river's island is across from the south shore area where Old Smithville was established in the ensuing years before the train arrived. Like a magnet, once the rails were laid, they encouraged a southerly migration as the city surrounded the railway. Railroad fuel storage tanks stand within the west legs of the "Y" intersecting tracks, while farther east, the railroad's roundhouse, turntable, and water storage tank can be seen. The "Tin Man" water tower standing watch over the river bridge still welcomes travelers to town.

ACROSS AMERICA, PEOPLE ARE DISCOVERING
SOMETHING WONDERFUL. *THEIR HERITAGE.*

Arcadia Publishing is the leading local history publisher in the United States. With more than 5,000 titles in print and hundreds of new titles released every year, Arcadia has extensive specialized experience chronicling the history of communities and celebrating America's hidden stories, bringing to life the people, places, and events from the past. To discover the history of other communities across the nation, please visit:

www.arcadiapublishing.com

Customized search tools allow you to find regional history books about the town where you grew up, the cities where your friends and family live, the town where your parents met, or even that retirement spot you've been dreaming about.